PENGUIN BOOKS

THE HUMAN FIGURE

Professor David K. Rubins, a graduate of Ecole des Beaux Arts and the Académie Julian in Paris, was for many years a teacher of sculpture and drawing at the John Herron Art School in Indianapolis. He has also been a Fellow of the American Academy in Rome, and his own work has been widely exhibited and praised throughout this country.

THE
HUMAN FIGURE

AN ANATOMY FOR ARTISTS

DAVID K. RUBINS

PENGUIN BOOKS

PENGUIN BOOKS
Published by the Penguin Group
Penguin Books USA Inc.,
375 Hudson Street, New York, New York 10014, U.S.A.
Penguin Books Ltd, 27 Wrights Lane, London W8 5TZ, England
Penguin Books Australia Ltd, Ringwood, Victoria, Australia
Penguin Books Canada Ltd, 10 Alcorn Avenue,
Toronto, Ontario, Canada M4V 3B2
Penguin Books (N.Z.) Ltd, 182–190 Wairau Road, Auckland 10, New Zealand

Penguin Books Ltd, Registered Offices:
Harmondsworth, Middlesex, England

First published in the United States of America
by Viking Penguin Inc. 1953
Viking Compass Edition published 1975
Published in Penguin Books 1976

Copyright by The Studio Publications, Inc., 1953
All rights reserved

LIBRARY OF CONGRESS CATALOGING IN PUBLICATION DATA
Rubins, David K. The human figure. (A Studio book) (A Penguin book)
I. Human figure in art. I. Title
[NC760.R9 1975] 743′.4 75-17693
ISBN 0 14 00.4243 1

30 29 28 27 26 25 24 23 22

Printed in Mexico

Set in Baskerville

PREFACE

The preparation of this book was undertaken primarily to present the factual material of artistic anatomy, as clearly as possible, in an easily used handbook. Such material alone may be sufficient for the artist using it only for reference or for the teacher of anatomy, but I feel that the student needs something more. In addition to the mere diagraming and cataloguing of the shapes of bones and muscles, the functional logic and basic design of the figure are also described. In parts of the text I have tried to describe and simplify the body's design; in the drawings of surface form I have intensified the characteristic shapes; and in the plates of the muscles and bones I have intended to intimate the beauty of the parts, the rhythm and the integrated character of the entire figure. I hope that my own enthusiasm for the human figure in art is in some degree evident and that it will stimulate a desire for thorough study. The importance of the figure in Western art has a long tradition, and I believe that a real understanding of anatomy is as necessary now as it has always been. A knowledge of human anatomy is as important for a sound basis for conventionalization as it is for abstraction or for the most detailed realism.

The information needed to understand the figure is presented primarily by drawings because the visual method of learning is the quickest and the most natural for the artist. The accompanying text is secondary and supplementary. The experience of teaching anatomy, drawing, and sculpture has suggested not only this method of presentation, but has helped me to determine what to include and what to omit. Enough material has been included to satisfy the needs of an exacting student and to offer to the artist the basis for making an intelligent simplification of his own. If it seems complex to the beginner, I am willing to let that impression remain as a statement of my belief that there is no easy way and no magic method to understand the human figure.

Specifically, the plates show the bones, muscles, and tendons which affect the surface form. These have been drawn with some modeling to suggest the mass of each form, and to make easier a visualization in three dimensions. The muscles have been drawn with the directions of their fibers indicated and their characteristic shapes simplified and exaggerated, suggesting their appearance when seen on a well-developed living man. Where several muscles group together, because of a common function or because they show on the surface as a unified mass, that unity has to some extent been indicated. The position of the forearm in the plates, the palm of the hand facing inward toward the leg, is different from the position illustrated in medical and many artistic anatomy texts. The position used in this book has the advantage of being the more natural one, the one most usually seen.

The medical names printed below the plates are included for the sake of accuracy and completeness. They are convenient for the students who already know them and for those who are familiar with the Latin language, because in many cases they describe the function, location, or shape of the muscles and bones. However, because medical terminology has no consistent logic, it is difficult to learn, and for the artist, not really necessary. In the descriptive text, the common names of muscles or bones are used wherever possible. Latin names are used wherever they help to avoid awkward or inaccurate description.

The text supplements the plates in several ways: by describing the functions of bones, the character and actions of their joints, and the attachments, grouping, and functions of muscles. Each of the parts is described, the length of description in most cases depending on the importance of the part. Where a muscle is shown incompletely in the drawings, or an attachment is either not clear or hidden, the text clarifies and completes the plates. The drawings which illustrate the actions of the joints show only the simplest movements and the most important activating muscles. This drastic simplification is adopted because a simple plan, illustrated, can be effectively and easily understood.

A chapter on proportion has been purposely omitted. The canons of proportion which were established in the past depended to a great extent on the tastes of contemporary fashion or merely on the preferences of individual artists or "schools." Because a sense of proportion is very personal it is best gained by the individual from a study of the great variety found in nature rather than from any composite or arbitrary idea. The drawings of the male and female figures at the back of this volume are not an attempt at either an average or an ideal; they are to illustrate the parts in the design of the whole figure and to indicate the major differences between the sexes.

I wish here to express my thanks to those who have given assistance in preparing this book. I am especially indebted to the members of the School Committee of the John Herron Art School and the Director, Mr. Donald Mattison, for their encouragement and active help.

Indianapolis, Indiana D.K.R.

CONTENTS

The Human Figure

THE HUMAN BODY

The human body is an extremely complex functioning entity, having its structure, movement, and organic functions related and interdependent. The artist, however, need be concerned only with those parts which affect the surface form: the skeletal structure, the principal muscles which hold it erect or activate it, and the over-all investment of skin and fat. Even such a partial study of the body can give a conception of its unity and functional design, its rhythm and proportion, and can also give an appreciation of its beauty, expressive in the figure as a whole, inherent and abstract in each of its parts.

The skeleton needs to be understood in its entirety because it dominates, directly or indirectly, all the surface form of the body and because the shapes of its joints determine all the movements. The muscular system, however, can be simplified. The deep muscles and most small ones can be omitted without losing the essential logic of their arrangement. In the same way, the infinite variety of movement of which the body is capable can be reduced to a simple plan of action at each joint.

BONES are formed in the process of human growth by the ossification of membrane or cartilage. This process continues until about the twenty-fifth year, when the adult skeleton is completely formed. Bone is a structure having a hard though slightly elastic outer shell made of dense porous tissue covering a lattice-work of slender fibers inside. Its outer surface is very smooth where it articulates with other bones and rough at the points of muscular attachment.

The shapes of bones differ according to the various functions they perform. They are heaviest where they support great weight, as the leg and pelvic bones; they have flattened or expanded surfaces for protection where they surround the three major cavities, cranium, chest, and pelvis; in the limbs, where motion is important, the bones are long with expanded articular surfaces at the extremities to strengthen the joints. The bones of the wrist and instep are numerous, closely and compactly grouped, so that the shocks received by the hand and foot can be transmitted to many surfaces and thereby lessened. Somes bones, notably the shoulder blade and vertebrae, have prominent projections, called *processes,* which serve as levers for the muscles which attach to them.

CARTILAGE is a firm gristly tissue found in many parts of the body. There are several types, which differ in composition and serve varying purposes. *Temporary cartilage* is a substance which ossifies to form the bones. The remaining types of cartilage here considered are all nonossifying and are permanently more or less elastic. One type is found in the nose, ear, Adam's apple, and the bands that con-

nect the front ends of the ribs to the breastbone. Two other types are associated with the joints. *Articular cartilage* is a thin sheet covering the articular surfaces of bone. It is slightly elastic, and its smoothness produces easy movement. *Fibrocartilage* is composed of cartilage cells intermixed with fibers which give it great elasticity. It is usually found in pads interposed between bones, serving to cushion shock and to allow slight movement of the joint.

LIGAMENT is a tough fibrous tissue, pliant but not elastic, which connects the bones to one another at their joints. The ligaments are disposed in many thin bands, which make a complex network, often interlaced, crossing over all the movable joints. They serve to strengthen the joints and hold the movable surfaces in contact. Flat in structure and taut, they almost never influence surface form. The ligaments have been omitted from the plates except in the two places where they are important, below the kneecap and at the base of the abdomen.

JOINTS, or *articulations,* are of three general types: the immovable joints; those allowing only slight motion; and the freely movable joints. The *immovable joint,* as found in the cranial and facial bones, has irregular and closely fitted joining surfaces, separated only by a very thin layer of connective tissue or cartilage. The *slightly movable joint* is one in which the joining bone surfaces are rather widely separated by an interposed pad of elastic fibrocartilage. The movement is effected only by the compression of the pad at one or another side; the bone surfaces themselves have no effect on the action. This type is found between the vertebrae where the pad serves to cushion shock as well as to allow the action. In the *freely movable joint* the bone surfaces are smooth and held in close approximation to one another, the movement being determined by the related shapes of the two surfaces. In this type of joint, each articulating surface is covered by a very thin layer of smooth articular cartilage, which facilitates the movement. The whole joint is enclosed by a *capsule,* or sac, of connective tissue which secretes a viscid lubricating fluid. Overlying the capsule are the connecting ligaments, which strengthen the joint and hold its surfaces in contact. In some of the freely movable joints there is also an interposed pad of elastic fibrocartilage to increase movement and absorb shock.

Several different types of motion are possible in the free joints. The *ball-and-socket joint,* as at the hip and shoulder, permits movement in every direction; it also allows *circumduction,* movement describing a cone, and *rotation,* the movement of the bone on its own axis. The *hinge joint,* as at the knee or elbow, permits movement in one direction, or in one plane only. It is usually formed by two convex surfaces placed side by side at the extremity of one bone, articulating with two concave surfaces on the adjacent end of the second bone. A variant of the hinge joint is found in the wrist, permitting free movement in one plane and restricted movement in a plane at right angles to the first. It is formed by an ovoid articular surface inserted into an elliptical cavity. This form allows the two movements mentioned above as well as a limited circumduction, but prevents the swivel motion of rotation. Two less common forms are the pivot and gliding joints. The *pivot joint* is found between the uppermost two vertebrae and at the articulation of the radius with the elbow. In both cases a pivot of bone is held within a ring shape formed by bone and ligament, allowing for rotation only. The *gliding joint* is found in the carpal and tarsal bones of the wrist and instep. The joining surfaces are very slightly concave and convex and the movement is limited.

The types of motion mentioned above are further defined by describing the movement of one part of the body in relation to other parts. *Flexion* is the act of bending, as at the elbow, when the hand is moved toward the shoulder. *Extension* is the act of straightening, in opposition to flexion, as the forearm moved to a position which continues the line of the upper arm. *Adduction* is the movement of a

limb toward the central axis of the body. *Abduction* is the movement of a limb away from the central axis of the body, as in raising the arm or leg to the side. *Lateral motion* describes the movement of the head or chest to the side, that is, tipping them away from the median plane passing through the center lines of the front and back of the body. Turning of the head or chest, however, is rotation. *Supination* is the movement of the forearm in turning the palm forward, when the arm hangs at the side. *Pronation* is the movement of the forearm in turning the palm toward the back, when the arm hangs at the side. *Inversion* is the movement at the ankle which turns the sole of the foot toward the center line of the body. *Eversion* is the opposing movement which turns the sole of the foot outward and to the side, away from the center line of the body.

MUSCLES, acting for the most part on the skeletal structure, move the parts of the body or hold them rigid. Connected to bone by tendon, and passing across one or more joints, they perform their function by contraction, exerting a pulling force only. They determine the superficial forms of most of the surface of the body. In action, the surface forms are changed by the contraction and thickening of the active muscles under tension and by the stretching, twisting, or compression of the pliant inert muscles. Muscle itself is a tissue composed of short fibers arranged for the most part parallel to one another but converging at their tendinous attachments.

Muscles are found in five typical forms: quadrilateral muscles have parallel fibers which are directed in straight lines from their origins to their insertions; fusiform muscles are tapered at either end in a spindle shape; triangular muscles have convergent fibers; bipennate and unipennate muscles have a central or lateral tendon toward which the fibers run obliquely from one or both sides, like the barbs of a feather; and lastly, circular muscles have fibers in a circular pattern, as around the mouth. Most muscles are joined to bone or cartilage at their points both of origin and of insertion by *tendons,* which are flat bands or round cords of strong nonelastic fibrous tissue. Some of the flat muscles end in wide sheets of tendon called *aponeuroses* which serve not only as connective tendons but also as sheaths for the muscles over which they pass. A few muscles, principally in the face, have origins from or insertions into ligament or skin, or connect by merging fibers with other muscles.

The *action of muscle* takes place by contraction of the muscular fibers, the direction of the muscular pull coinciding with the direction of the fibers. The tendon usually continues the muscular direction, connecting it to the bone in a direct line. In that case, the resultant force on the bone is in the direction of the muscle pull. This can be illustrated by the teres major, which arises from the shoulder blade and is inserted into the arm bone below the shoulder joint; the arm bone acts as a lever and the shoulder joint as a fulcrum. If, however, the tendon is deflected out of line, as the tendons of the fingers are deflected as they bend over the knuckles, the resultant force on the fingers is at a contrary direction from the muscular pull, as in a pulley arrangement. In the case of muscles where the fibers run in varying directions and have extensive attachments, as the trapezius, the action will be a composite result of actions in several directions. However, the action in one or more of those directions may be offset and nullified by other muscles, allowing free activity in only one part. Or further, only one part of the muscle may be activated, the remainder being inert.

Only in a general way can individual muscles be considered as single mechanical units, because for every action a whole complex of muscles is brought into play. One or more muscles will be the primary moving force; other muscles will immobilize joints not needed in the action (as in the case of an acting muscle passing across more than one joint); and still others adjust and stabilize the equilibrium of the body. Further, the same muscle will act on one or another of two bones depending on which bone is fixed. If the upper arm is fixed, the biceps will raise the forearm; if the forearm is fixed, as in climbing,

the biceps will move the upper arm and raise the body. The artist need be familiar only with the simple motions of each joint and with muscles constituting the primary moving force for each action.

FASCIA. Covering the body just beneath the skin are two layers of fascia, deep and superficial. The *deep fascia* is a strong thin tendonlike inelastic membrane which not only invests the whole body but binds down individual muscles and groups as well. It becomes thicker in places, particularly at the joints, where it has a marked constricting effect, holding the tendons firmly in place during action. Covering the deep fascia, and adherent to it, is the *superficial fascia*. Though similar to the deep fascia, it is loose, less dense, and less tendinous. It contains a few subcutaneous muscles and the surface fat, hence it varies greatly in its thickness. It is usually thin in the area of the face and neck; it is very thick and more fibrous in the scalp, palm of the hand, and the sole of the foot.

SURFACE FAT, disposed within the superficial fascia, directly affects the surface form of the body. It tends to obscure the smaller muscles, to unify and smooth the contours, and to produce independent forms by accumulating heavily in certain places. In babies, the accumulation near the joints of the limbs is heavy, though deeply creased at the joints themselves. In the adult female, the smaller bone structure and less developed musculature tend to increase the importance of fat as a determinant of form. Most noticeably, fat collects in a more or less distinct form situated at the lower outside border of each buttock, to such an extent that the greatest width across the hips in the female is at a point below the head of the thigh bone, tending to increase the apparent length of the trunk.

Less marked, but nevertheless producing shape independent of muscular or bone form, fat accumulates high on the back of the upper arm, on the spine at the base of the neck, at the back of the knee, beneath the kneecap, and to a slight degree beneath the inner portion of the knee adjacent to the shin bone. At other places fat accentuates the underlying existing form, marking more clearly the female sexual characteristics, particularly at the iliac crest widening the hips, at the abdomen and buttocks increasing the obliquity of the pelvis, and at the breasts.

THE HEAD AND NECK

For the artist, the head and neck must be considered together. This division of the body is somewhat arbitrary because the bones of the neck are also to be considered as a part of the trunk. In the same way, some of the muscles in the neck are in reality extensions of trunk muscles. This difficulty in making arbitrary divisions obtains elsewhere in the human body because no one part can logically be considered independent of its adjacent part.

THE BONES OF THE HEAD

The bones of the head, or *skull,* are individually very complex in shape and, with the exception of the lower jaw, are rigidly held together by immovable joints. Their joining edges are irregular and interlocked. They can be divided into two groups: the bones of the cranium, which enclose and protect the brain, and the bones of the face. The principal *bones of the cranium* are six in number: the occipital, the frontal, two parietal, and two temporal.

The *occipital bone* forms the bottom and back of the cranium, its undersurface being rough and ridged to provide attachments for the muscles of the neck. At the center of this undersurface is a large round opening through which the spinal cord connects with the brain. On either side of this opening are two rounded prominences which articulate with the atlas, the top vertebra of the spine.

The *frontal bone* is at the front of the cranium, forming the brow, and includes the prominent protective arches over the eyes. On either side, and covering the top of the skull, are the two *parietal bones,* while the lower part of the sides of the cranium are formed by the *temporal bones*. It is from the temporal bone that the *mastoid process* projects downward back of the ear. The principal *facial bones* are the two zygomatic bones, the two maxillae, and the mandible. The *zygomatic bone* forms the prominence of the cheek bone below the outer corner of the eye and also the front part of the zygomatic arch, beneath which the temporal muscle passes. The two *maxillae* form the *upper jaw* and the *mandible* the *lower jaw*. The mandible articulates with the skull beneath the zygomatic arches immediately in front of the ears, the two points of contact forming a hinge joint.

THE BONES OF THE NECK

The bones of the neck are the seven *cervical vertebrae,* comprising the upper portion of the spine. Placed one on top of another, they form a column which curves forward from the back of the rib cage to

the base of the skull, joining it slightly behind its center of gravity. This column supports the skull and makes possible the free movements of the head. The six lowest of these vertebrae are similar in general structure to the other vertebrae of the spine. They have a short cylindrical major portion, or *body,* to which is appended at the rear a bony arch, enclosing the spinal cord. From this arch project three bony processes, two *transverse processes* and one directly to the rear called the *spinous process.* The spinous process of the lowest of the neck vertebrae is longer than the others and shows on the surface form.

The topmost vertebra, the *atlas bone,* is distinguished by having no body, but is in the form of a somewhat triangular ring. On its upper surface are two concave hollows which articulate with the two rounded projections on the underside of the occipital bone. The skull is tipped forward and back by a rockerlike motion performed at this joint.

The rotation of the skull—that is, turning the head from side to side—is accomplished by the atlas bone rotating upon the vertebra immediately beneath it, the skull and atlas rotating together. The movements of the neck proper, extension (bending backward), flexion (bending forward), and lateral motion are the result of the slight motion taking place between each of the six lowest vertebrae. A thick pad of elastic cartilage between the bodies of the vertebrae makes these movements possible. The *hyoid bone* is suspended in the muscles of the front of the neck, affording attachments for muscles which depress the jaw and effect movements of the tongue and throat. The *thyroid cartilage,* the prominence known as the Adam's apple, is a protector of the larynx.

THE MUSCLES OF THE HEAD

The largest muscles are those which act upon the lower jaw, the only movable bone of the skull. In mastication the lower jaw is lifted by the temporals and masseters of the head and depressed by muscles of the neck, described later. The *temporalis* arises from a broad area at the side of the cranium, its fibers passing inside the zygomatic arch, and is inserted into the bony process of the lower jaw which projects in front of the articulation. The *masseter* arises from the lower border of the zygomatic arch and is inserted into the mandible at the angle of the jaw. Both muscles have a considerable leverage and consequently exert great force in closing the jaw.

Other facial muscles are so numerous and interwoven and their functions so varied in order to accomplish facial expression that a description of them is hardly worth the artist's attention. The important ones have been illustrated and named in the plates. It is worth while, however, to note that a few of them have no bony attachments whatever, being invested in the skin or superficial fascia. Others arise from bone but are inserted into skin, fascia, cartilage, or the fibers of other muscles.

THE MUSCLES OF THE NECK

The muscles of the neck illustrated in the plates can be divided into two groups composed of those muscles which connect to the hyoid bone and those which connect to the skull and neck vertebrae.

The *first group* comprises three muscles: the digastricus, omohyoideus, and sternohyoideus, each muscle having its counterpart on the opposite side of the neck. The *digastricus* arises from the inner surface of the mastoid process and passes downward and forward to the hyoid bone, to which it is attached by tendon. From this point it continues upward and forward, to be inserted into the inner surface of

14

the lower jaw at the chin. The *sternohyoideus* arises from the inner surfaces of the collar- and breast-bones and is inserted into the underside of the hyoid bone. The *omohyoideus* arises from the top edge of the shoulder blade, passes beneath the mastoid muscle, and at that point turns obliquely upward to attach also to the hyoid bone. The primary action of these three muscles is to elevate or depress the hyoid bone, which in turn moves the base of the tongue, an action necessary in swallowing. Their secondary function is to depress the lower jaw.

The *second group of muscles of the neck* (illustrated in the plates of the trunk as well) acts upon the skull and neck vertebrae. The deeper muscles of this group are the splenius capitis, levator scapulae, and scalenus medius; the more superficial muscles are the trapezius and sternocleidomastoideus. The *splenius capitis* arises from the spinous processes of the lowest neck vertebra and of several chest vertebrae. Its fibers pass obliquely upward and are inserted into the base of the skull. The primary function of this muscle is to tip the skull backward and it assists in inclining the head to the side. The *levator scapulae* arises from the transverse processes of the four topmost vertebrae and is inserted into the angle of the shoulder blade lying closest to the neck. It assists in bending the neck to the side. The *scalenus medius* arises from the transverse processes of the lowest six neck vertebrae and is inserted into the upper surface of the first rib. Because of its insertion into the rib at some distance from the axis of the spine, it exerts a strong pull and is the principal muscle inclining the neck to the side. The three muscles mentioned above very seldom show on the surface form except when the head is turned far to the side.

There is another deep muscle of the neck, the *longus capitis,* which has the primary function of tipping the skull forward. It is buried so deep within the neck that it never shows, and for that reason it has been illustrated only in the plate showing the functions of the neck. (See page 20.)

The two superficial muscles of the neck to be described are prominent and show on the surface of the cylindrical shape of the neck. The *trapezius* is primarily a muscle of the trunk, consequently only the upper portion will be described here. Its upper fibers arise from the base of the skull at the back, descend vertically and, at the base of the neck, turn abruptly to the side to be inserted into the outer portion of the collarbone and the spine of the shoulder blade. The two trapezius muscles, one on each side of the spine, form the flat vertical plane at the back of the neck. In adolescence and old age they appear separated and well defined. Operating together, they tilt the skull backward; separately, they assist inclination of the head to the side; in conjunction with the mastoid muscle of the same side, they rotate the head. The *sternocleidomastoideus* is the most prominent muscle of the neck. It arises by two heads, from the breastbone by a strongly marked cord at the pit of the neck, and from the collarbone. The two heads merge into one large rounded muscle which is directed obliquely upward to be inserted into the mastoid process. When the head is turned to the side, the muscle shows prominently along its entire length. When only one mastoid muscle functions, it turns the head, being assisted by the trapezius of the same side.

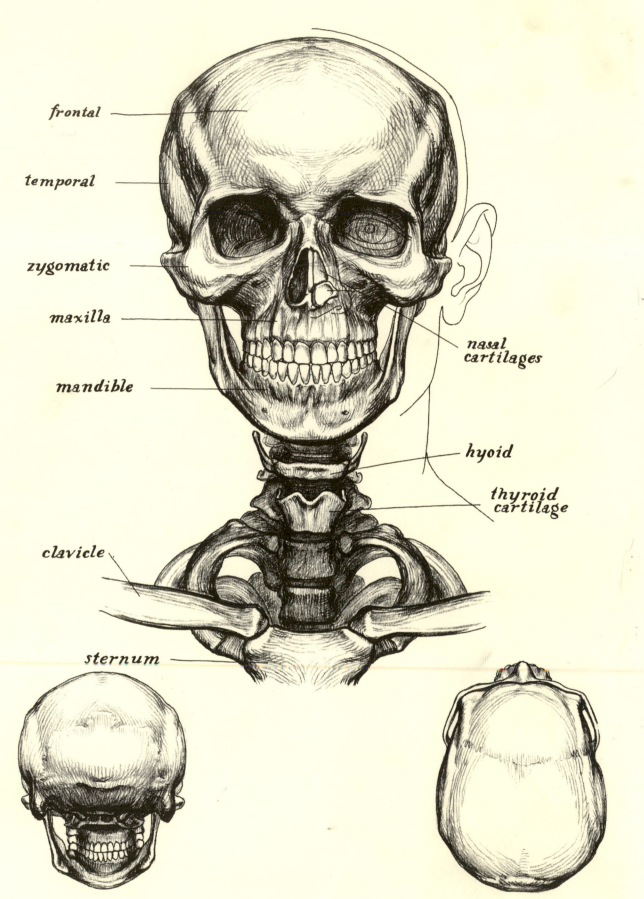

frontal

temporal

zygomatic

maxilla

mandible

nasal
cartilages

hyoid

thyroid
cartilage

clavicle

sternum

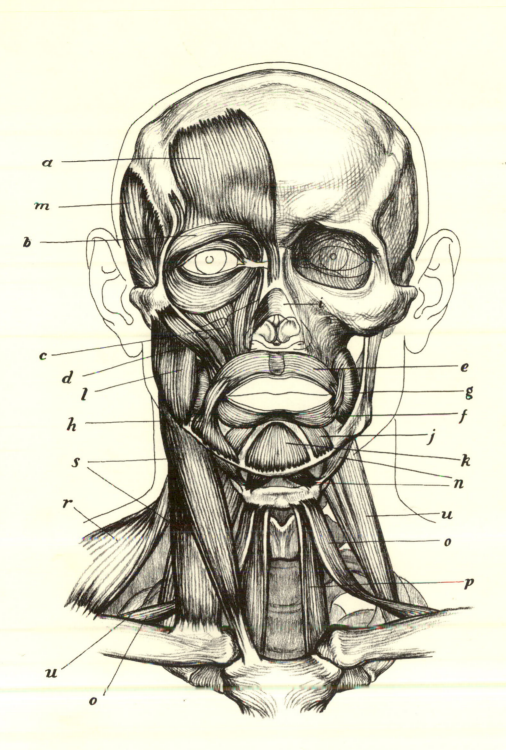

a. Frontalis
b. Orbicularis oculi
c. Quadratus labii superioris
d. Zygomaticus
e. and f. Orbicularis oris
g. Buccinator (fibers merge with orbicularis oris)
h. Triangularis (fibers merge with upper part of orbicularis oris)
i. Nasalis
j. Quadratus labii inferioris

k. Mentalis
l. Masseter
m. Temporalis
n. Digastricus
o. Omohyoideus
p. Sternohyoideus
r. Trapezius
s. Sternocleidomastoideus
u. Scalenus medius

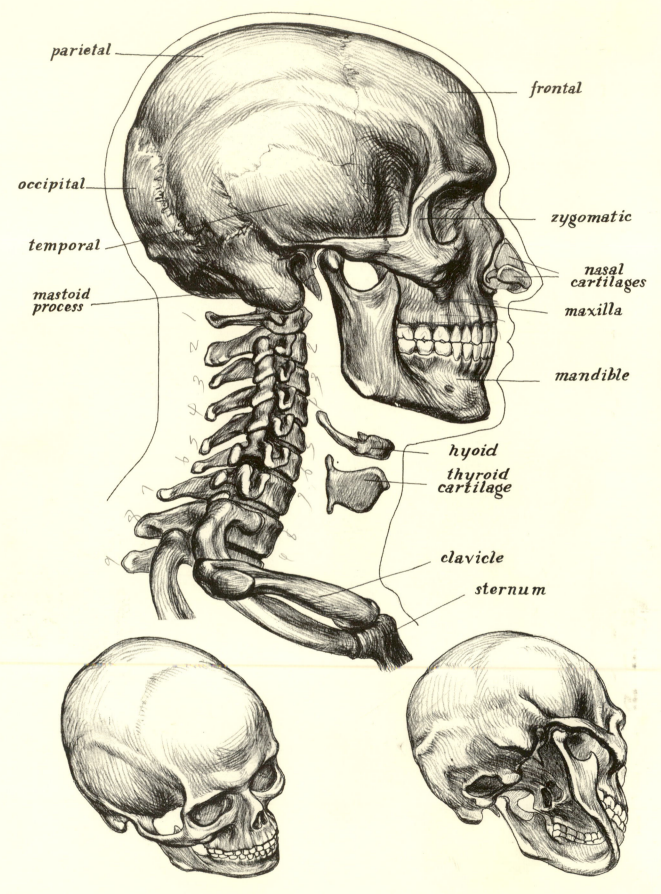

parietal

frontal

occipital

zygomatic

temporal

nasal
cartilages

mastoid
process

maxilla

mandible

hyoid

thyroid
cartilage

clavicle

sternum

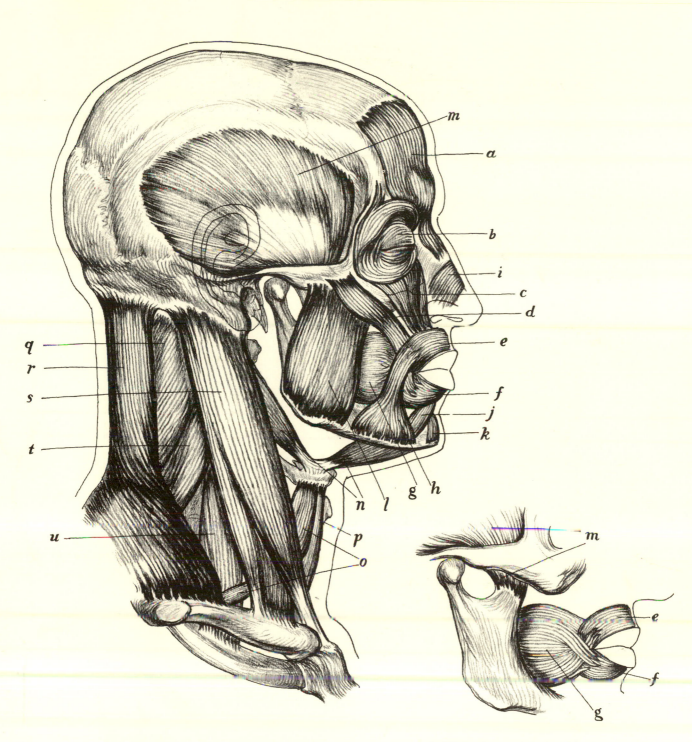

a. Frontalis
b. Orbicularis oculi
c. Quadratus labii superioris
d. Zygomaticus
e and f. Orbicularis oris
g. Buccinator (fibers merge with orbicularis oris)
h. Triangularis (fibers merge with upper part of orbicularis oris)
i. Nasalis
j. Quadratus labii inferioris
k. Mentalis

l. Masseter
m. Temporalis
n. Digastricus
o. Omohyoideus
p. Sternohyoideus
q. Splenius capitis
r. Trapezius
s. Sternocleidomastoideus
t. Levator scapulae
u. Scalenus medius

THE MOVEMENTS OF THE NECK

The neck is a joint capable of motion in all directions: flexion and extension (movement forward and backward), lateral motion (inclination of the head toward the shoulder), rotation (turning the head), and circumduction, not illustrated, which is a combination of all movements. See pages 13 and 14 for a complete description of the joint.

 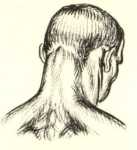

FLEXION. Longus capitis (a deep muscle not shown in plates elsewhere).

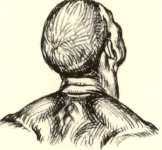 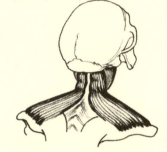 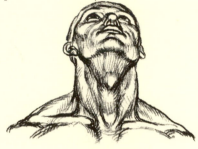

EXTENSION. Splenius capitis and trapezius.

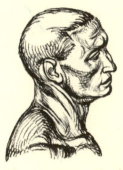 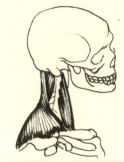 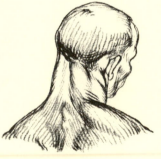

LATERAL MOTION. Scalenus medius, splenius capitis, and trapezius.

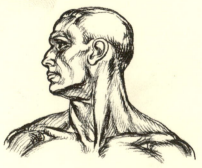 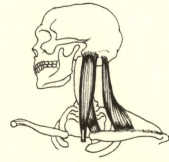

ROTATION. Sternocleidomastoideus and the front fibers of the trapezius. In this motion the head also tips backward slightly.

THE TRUNK

The trunk in man is erect. This physical characteristic most clearly distinguishes man from the four-footed animals. The structural changes which have developed during man's evolution are partly evident in the general shape of the trunk. His head and chest are supported by the spine instead of hanging from it. His shoulders, no longer needed for support, are wide apart, increasing the usefulness of the arms; the chest cavity is wide rather than deep; and the pelvis thickened and expanded. Man's distinctive carriage, therefore, is determined by the skeleton of the trunk.

THE BONES OF THE TRUNK

The bones of the trunk can be conveniently divided into four parts: the spine, the rib cage, the shoulder girdle, and the pelvic girdle. The spine is the central axis around which the other parts of the skeleton are grouped. The skull, rib cage, and pelvic girdle are directly connected with it; the shoulder girdle, arms, and legs are only indirectly connected with it.

THE SPINAL COLUMN itself is made up of thirty-three small bones or *vertebrae,* the lowest nine of which are united with one another in the adult to form two bones. The lowest four bones at the base of the spine fuse together to form the terminal bone or *coccyx.* The next five above fuse into the *sacrum,* a wide *V*-shaped bone to which the two hip bones of the pelvic girdle are firmly attached. The sacrum provides a strong supporting base for the remaining twenty-four vertebrae of the spine, each separate and movable. The movable vertebrae, with the exception of the topmost (atlas bone), all have a similar construction, though they vary somewhat in size and shape. The main part, or *body,* of each vertebra is of cylindrical shape from which an arch of bone projects to the rear, forming a more or less circular hole between it and the body of the vertebra. Projecting from this arch are several small prominences which articulate with adjacent vertebrae, and also three long processes for muscular attachments. These *processes* act as levers; two of them are *transverse* and extend to the sides; and one, the *spinous process,* projects backward from the center of the arch.

The bodies of the vertebrae rest upon one another separated by a fibrous pad of elastic cartilage which serves as a cushion and allows movement between the bones. The arches, one above the other,

21

together form a canal enclosing the spinal cord. The *atlas bone* differs from the other vertebrae by having no body. Its principal part is shaped like a triangular ring, having two hollow surfaces for articulation with the skull. The movable vertebrae are divided into three groups: the lowest five, in the region of the small of the back are the *lumbar vertebrae*; the next twelve above are the *thoracic, or chest, vertebrae,* to which the ribs attach; the remaining seven, at the top, are the *cervical,* or *neck, vertebrae.*

Seen laterally, the spine forms a series of curves that are structurally logical and determine the major directions of the trunk as a whole. The coccyx and sacrum together describe a curve toward the back, allowing room for the organs within the pelvic girdle. The lumbar vertebrae curve in a contrary direction, toward the front, in order to get under the center of gravity of the chest which they support. The chest vertebrae curve backward to become the back part and support of the chest wall formed by the ribs. The neck vertebrae curve again toward the front and support the skull very nearly at its center of gravity. These four curves give a construction to the spine which is both strong and springy, well suited to absorb the shocks of walking and jumping.

Although some movement is possible between each of the vertebrae, the amount of movement varies in different regions of the spine. The freest movement is in the cervical, or neck, region, where extension and lateral movement are extensive. Flexion, or movement of the neck forward, is restricted by the jaw coming into contact with the front part of the chest wall. In the thoracic region, movement is restricted by the rib structure which resists any great amount of expansion or contraction between its parts. In the lumbar region almost no lateral movement is possible, only slight extension, because of the length and size of the spinous processes; but flexion, the body bending forward at the waist, is very free. Rotation of one vertebra upon another is extremely slight except between the topmost two, where there is free movement allowing rotation of the skull.

THE RIB CAGE, or *thorax,* is a barrel-like structure, smaller at the top than at the bottom, composed of twelve pairs of ribs and the sternum, or breastbone. Its function is to enclose and protect the lungs and heart with a movable cage which can expand and contract with respiration and also to provide a support for the shoulder girdle. The uppermost ten pairs of ribs are called the *true ribs* and are joined to the vertebrae at the back and to the breastbone in front. The head of each true rib articulates with the vertebra at its body, from which point it curves to the side and backward to articulate as well with the transverse process of the vertebra. It then curves to the side and downward, joining the breastbone at the front of the chest wall by means of a bar of cartilage. The eighth, ninth, and tenth ribs connect only indirectly to the breastbone because their cartilages join the cartilage of the seventh rib. It is this cartilage which usually shows on the surface form as an arch beneath the chest muscles. The floating or *false ribs,* the lowest two pairs, are articulated with the bodies of the vertebrae only, and have no connection with the breastbone. They do not show on the surface form.

The *sternum, or breastbone,* is composed of three bones which are usually so firmly joined together in the adult that the sternum can be considered a single bone. It is at the upper extremity of the sternum that the shoulder girdle joins the body, the collarbone articulating with the sternum just above the connection of the topmost rib. This complex framework of the rib cage is essentially barrel- or egg-shaped, its dimensions, in the adult, being somewhat greater from side to side than from front to back. The larger bottom half determines the general form of the trunk in the region immediately above the waist.

The bellowslike movement of the rib cage as a whole is slight, but in simple terms, it amounts to expansion and contraction of the chest wall, the sternum rising in expansion as the lungs are filled.

THE SHOULDER GIRDLE consists of two collarbones and two shoulder blades, which form a movable bony structure projecting to either side of the rib cage. The purpose of the shoulder girdle is to afford a connection for the arms to the body, as the pelvic girdle affords a connection for the legs. Although the two limb girdles are similar in purpose, they are very different in construction. The shoulder girdle is movable, thereby increasing the mobility and usefulness of the arms; the pelvic girdle is rigid and strong to transmit the weight of the body to the supporting legs. Each half of the shoulder girdle connects to the skeleton at only one point. This single articulation is at the pit of the neck; the *clavicle,* or *collarbone,* joins the breastbone there in a joint capable of considerable movement. From this point at the front of the chest, the collarbone curves first backward, conforming somewhat to the curve of the ribs, then reverses itself and extends to the side. At its outer extremity it articulates with the shoulder blade. Hence the shoulder blade has no direct articular connection to the body; it is only indirectly joined by virtue of its connection with the collarbone.

The *scapula,* or *shoulder blade,* is, in its principal part, a thin triangular plate of bone curved to conform to the shape of the back of the rib cage close to which it lies. At its outer angle is the shoulder joint, a shallow concave articular surface which accepts the convex head of the upper arm bone. Two bony projections arise from the triangular plate of the shoulder blade. The larger one, the *spine of the scapula,* is a ridge of bone arising from the back surface. It extends upward and to the side, terminating in an expanded surface called the *acromion process.* This process articulates with the collarbone, and at their juncture the two bones form a protective shield over the shoulder joint. The smaller projection arising from the triangular plate of the shoulder blade is the *coracoid process.* It projects forward from the outer angle of the triangle, serves as a protection at the front of the shoulder joint, and affords attachment to two muscles of the upper arm.

These extended processes and the broad expanse of the shoulder blade afford strong levers and ample attachments for the muscles of the shoulder. The acromion process and spine of the shoulder blade and the collarbone as well are superficial, appearing on a lean model as bony ridges, clearly marked. As seen from above, these ridges appear as a *V,* one segment coming from the front of the body and one from the back to unite over the arm bone. The movements of the shoulder girdle all originate from its one connection to the body, at the pit of the neck. The total movement of the shoulder girdle results from the motion of the collarbone joined to the ribs, supplemented by the motion of the shoulder blade joined to the free end of the collarbone. The loose muscular connection of the shoulder blade to the ribs allows it to slide freely over the surface of the back.

THE PELVIC GIRDLE, or *pelvis,* consists of two hip bones, one on each side, and the *sacrum* of the spine. The two *hip bones* are united in front by an immovable joint and united at the back by the sacrum. Together these three bones form a ring which transmits the weight of the trunk to the legs. The hip bone in infancy is actually three separate bones, the ilium, ischium, and pubis, which fuse together in the adult. The upper portion of each hip bone is formed by the *ilium,* an extensive flange flaring outward which terminates above in an irregularly curved edge called the *iliac crest.* This crest is superficial along its entire length, being well marked in the male, and serves as a dividing line between the trunk and hip at the side of the body. The lower part of each hip bone is formed by the pubis in front and the ischium behind. The *pubis* projects forward to meet the pubis of the other hip bone at the base of the abdomen.

23

The *ischium,* situated behind the pubis, does not affect the surface form at any point. (See pages 63–64 for a fuller description.) On the lower outside surface of the hip bone is a deep articular cavity into which is inserted the head of the upper leg bone. The depth of the cavity restricts mobility of the leg bone but provides the strength to support the body weight. The expanded surfaces of the hip bone protect the organs which they enclose, forming a sort of basin to support them as well, and afford broad attachments for leg, hip, and trunk muscles.

THE MUSCLES OF THE TRUNK

The muscles of the trunk can be divided into two principal groups: one group at the lower part of the trunk, extending from the rib cage to the pelvis, controls the motion at the waist; and a second group at the upper part of the trunk acts upon the shoulder girdle and upper arm.

The *muscles at the lower part of the trunk* are three in number, each muscle of course paired with a similar muscle on the opposite side of the body: the sacrospinalis at the back, the rectus abdominis at the front, and the obliquus externus abdominis at the side. The *sacrospinalis* arises from the sacrum, the lower lumbar vertebrae, and the posterior end of the iliac crest; and its fibers are directed upward to divide into three parallel columns called the *spinalis dorsi,* the *longissimus dorsi,* and the *iliocostalis.* They terminate in many insertions into the ribs and into the spinous and transverse processes of the chest and neck vertebrae. The sacrospinalis is thickest at the small of the back where it is always evident on the surface form. It serves to strengthen the spine, hold the body erect, and arch the back and extend the neck.

Opposing the sacrospinalis at the front is the *rectus abdominis,* extending from the pubis to the ribs. The fibers are interrupted in their length by fibrous bands which produce horizontal furrows in the surface form, two of which are usually evident in the male. This rectus muscle is completely covered by a thin tendinous sheath, the aponeurosis of the obliquus externus abdominis. For the sake of clarity in the plates, this sheath has been omitted except for a few lines extending over the rectus muscle to indicate its presence. The rectus muscle is considerably thickened in the region of the navel to produce in the surface form a fullness at the top of the abdomen. The function of the rectus abdominis is to bend the body forward at the waist.

The *obliquus externus abdominis* arises from the eight lower ribs; the origins on the ribs form a series of steps. Most of its fibers are inserted into the front two-thirds of the iliac crest, but the fibers of its own front portion end in the aponeurosis mentioned above which extends to the crest of the pubis and to the center line of the body where it joins the aponeurosis of the opposite side. Its strong cord-like lower border is called the *inguinal ligament.* The muscle is thin above, where it overlies the ribs, but below, it becomes considerably thicker, forming a well-defined parallelogram. Its lower border closely follows the line of the iliac crest. The action of this muscle bends the body to the side.

The *muscles of the upper part of the trunk* must be divided into three subsidiary groups, as follows:

24

the muscles which arise from the ribs or spine and attach to the shoulder girdle; those which arise from the ribs or spine and attach directly to the arm, having only an indirect action on the girdle; and those which arise from the girdle itself and are attached to the arm.

The *first subsidiary group* comprises four muscles, the rhomboideus major and minor (here considered as one muscle), the levator scapulae, the trapezius, and the serratus anterior. The *rhomboideus major* and *minor* arise from the spinous processes of the lowest neck vertebra and the uppermost four chest vertebrae and are inserted into the edge of the shoulder blade nearest the spine. The *levator scapulae* arises from the transverse processes of the upper neck vertebrae and is inserted into the edge of the shoulder blade immediately above the insertion of the rhomboids. Although these three muscles are almost entirely covered by the trapezius, they do influence the surface form indirectly, and they act together as rotators of the shoulder blade.

The *trapezius*, the superficial muscle at the upper and back parts of the neck and shoulder, arises from the base of the skull and from the spinous processes of the lowest neck vertebra and of all the chest vertebrae. Its fibers are generally converging and are inserted into the outer third of the collarbone and into the acromion process and spine of the shoulder blade. The upper fibers of this muscle, in the neck, form a more or less vertical post analogous to the supporting post of the sacrospinalis at the small of the back. The intermediate portion is heavy, forming a slanting shelf at the top of the shoulder. The lowest portion of the muscle is thin, conforming generally to the edge of the shoulder blade and the roundness of the rib cage. In the region of the base of the neck the shape of the tendon produces a noticeable depressed area, strongly marked when the muscular fibers arising from it are contracted and thick. In this depression the projection of one or two spinous processes of vertebrae can be seen. The extensive attachments and diverse directions of the fibers give the trapezius a variety of functions: it bends the head back, both raises the shoulder and pulls it backward, and its lower part rotates the shoulder blade.

The *serratus anterior* comprises a number of separate strips of muscle which arise from the ribs and pass between the chest wall and the shoulder blade to be inserted into the inner surface of the back edge of the shoulder blade. As the shoulder blade completely covers the upper strips of this muscle, they are disregarded here and are not shown in the plates. Only the lower seven strips are shown. These seven converge in a fan shape and are inserted close to the lower angle of the shoulder blade. The origins of the lower four or five are integrated into the steplike upper border of the obliquus externus abdominis. Here the muscle is superficial, showing on the surface form as a series of fleshy points, most noticeable when the arm is raised. In that action the muscle is contracted as it pulls forward and raises the lower corner of the shoulder blade, a movement necessary to allow the arm to be raised high. The actions on the shoulder girdle of the four muscles of this group are extremely varied. By moving the shoulder girdle, to which the arm is articulated, they add greatly to the arm's range of action and usefulness.

The *second subsidiary group of upper trunk muscles* comprises two muscles, both of which arise from the trunk, by-pass the shoulder girdle, and are inserted directly into the arm. They are the pectoralis major and latissimus dorsi. The *pectoralis major* should not technically be included in this group because the upper fibers of the pectoral arise from the shoulder girdle at the inner half or two-thirds of the collarbone. However, in spite of this exception, the muscle can be considered to arise from the chest wall. Its complete attachment is from the collarbone as stated above, from the breastbone, and from

25

the upper part of the aponeurosis of the obliquus externus abdominis. From these attachments the fibers converge, the lower fibers twisting under the upper at the armpit to give the greatest thickness to the muscle at that point, and are inserted into the upper arm bone sufficiently below its head to give a powerful leverage. The fibers are arranged in rather distinct bundles, so that occasionally the muscle will be divided by one or more furrows showing on the surface form. The contours of the muscle itself are usually distinctly marked, except above the armpit where it tends to merge with the form of the deltoid. In the female, the lower border is completely obscured by the breast. The principal action of the muscle is to bring the arm forward.

The *latissimus dorsi* is more or less triangular in shape and its fibers, like those of the pectoral, twist just before the insertion. It arises from the spinous processes of the lowest eleven vertebrae, from the sacrum, and from the back end of the iliac crest. The tendon of attachment to the lower part of the muscle is very long, covering the small of the back. The muscle fibers extend obliquely upward and converge, pass between the rib cage and the arm, where they twist upon themselves and are inserted into the front of the arm bone just above the insertion of the pectoral. The upper fibers of the muscle overlap the lower angle of the shoulder blade and the teres major, giving the appearance of being held in a sling. Although the muscle is superficial throughout, except at the point where it joins the arm, its surface form is determined by the shape of the ribs, the teres major, and the sacrospinalis which lie beneath it. Its primary action is to pull the arm backward, and in concert with the pectoral and teres major the muscle pulls the arm down and in toward the body.

The *third subsidiary group of upper trunk muscles* comprises those which arise from the shoulder girdle and are inserted into the arm. This group consists of three muscles, the deltoideus, infraspinatus, and teres major. The *deltoideus* arises from the spine of the shoulder blade, the acromion process, and the outer third of the collarbone. The fibers pass downward over the head of the arm bone and the coracoid process of the shoulder blade, are gathered together to give the muscle its characteristic triangular shape, and are inserted into the outside surface of the upper arm bone. The surface shape of the muscle is influenced at the side and front by the head of the arm bone, while the muscle itself is thickest at a point below that head. Therefore, in a person of considerable muscular development, the greatest width across the shoulders will lie at the point where the muscle is thickest; but, with a meager development, the greatest width will occur higher, at the projection of the head of the arm bone. If the central fibers of the deltoideus are contracted, the arm will be raised from the side; the front and back fibers, acting independently, help to bring the arm forward and backward respectively. The *infraspinatus* arises from the back border of the shoulder blade below its spine and is inserted into the head of the arm bone. Neither its influence on the surface form nor its action in rotating the arm is important. The *teres major,* lying directly below the infraspinatus, is a thick and frequently prominent muscle arising at the lower angle of the shoulder blade. The fibers from that point are directed obliquely upward, pass between the arm and the rib cage and are inserted into the front surface of the shaft of the arm bone. The lower half of the muscle is covered by the upper fibers of the latissimus dorsi which here conform to the shape of the teres major. The bulk of the two muscles at this point forms the fullness at the back of the armpit. They assist one another in pulling the arm backward.

The shoulder blade and its muscles, reduced to their simplest form, appear as an essentially triangular mass superimposed on the back of the rounded shape of the rib cage. The shoulder itself appears as the outer corner of this triangle; the lower border is marked by the teres major; the upper border is marked by the spine of the shoulder blade and the thick mass of the trapezius immediately above it.

Opposite this triangular mass, superimposed on the front of the rib cage, is the pectoral or chest muscle, more rectangular in shape. These more or less distinct angular forms characterize the upper part of the trunk, in contrast to the rounded shape of the rib cage which is the dominating feature of the lower part of the trunk.

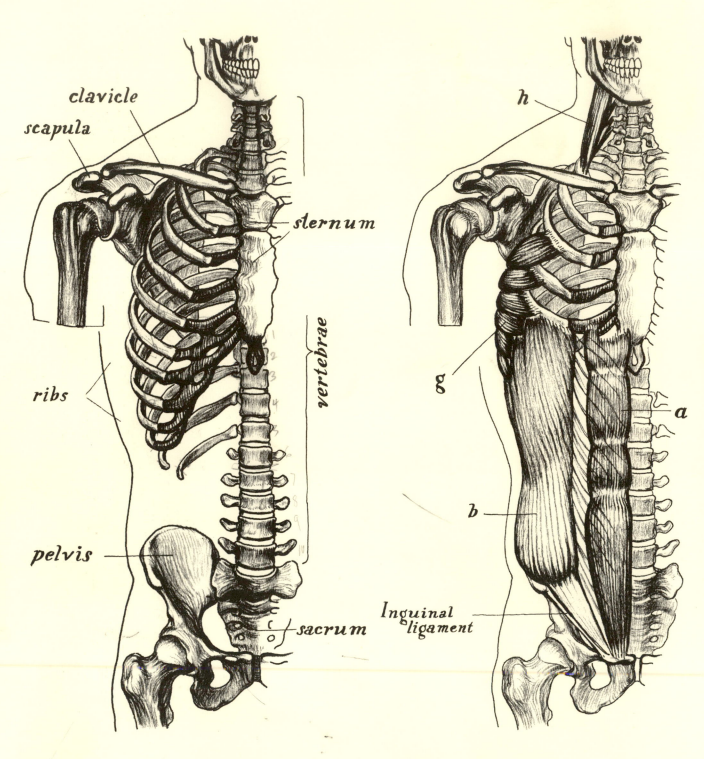

clavicle

scapula

sternum

vertebrae

ribs

pelvis

sacrum

h

g

a

b

Inguinal
ligament

a. Rectus abdominis
b. Obliquus externus abdominis (with an indication
 of the aponeurosis which extends from this mus-
 cle to cover the rectus abdominis)

g. Serratus anterior
h. Scalenus medius

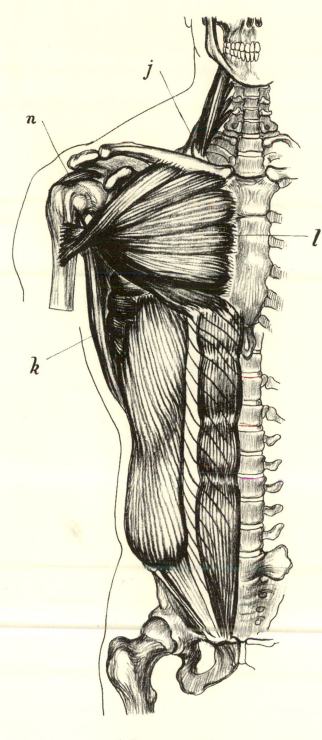 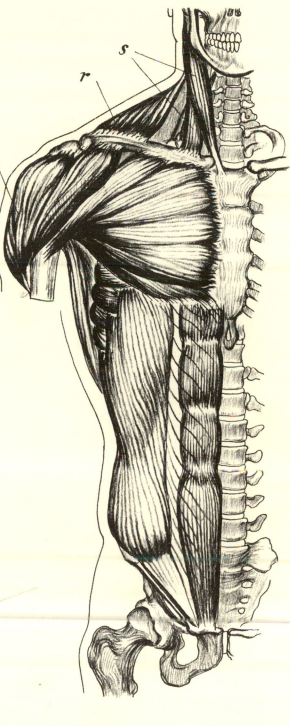

j. Levator scapulae
k. Latissimus dorsi
l. Pectoralis major
n. Infraspinatus

q. Deltoideus
r. Trapezius
s. Sternocleidomastoideus

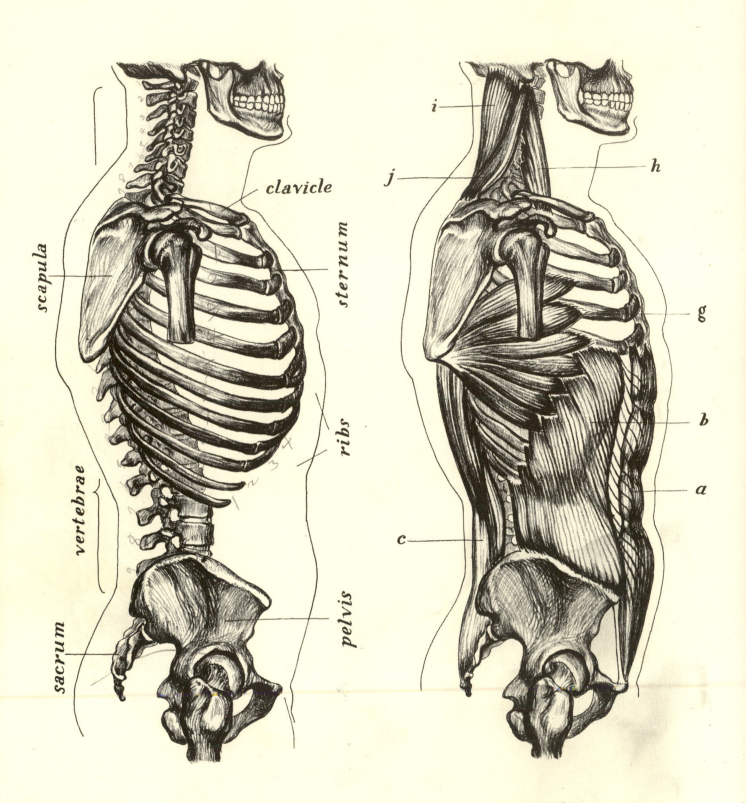

scapula

clavicle

sternum

ribs

vertebrae

pelvis

sacrum

i

j

h

g

b

a

c

a. Rectus abdominis
b. Obliquus externus abdominis (with an indication
 of the aponeurosis which extends from this mus-
 cle to cover the rectus abdominis)
c. Sacrospinalis

g. Serratus anterior
h. Scalenus medius
i. Splenius capitis
j. Levator scapulae

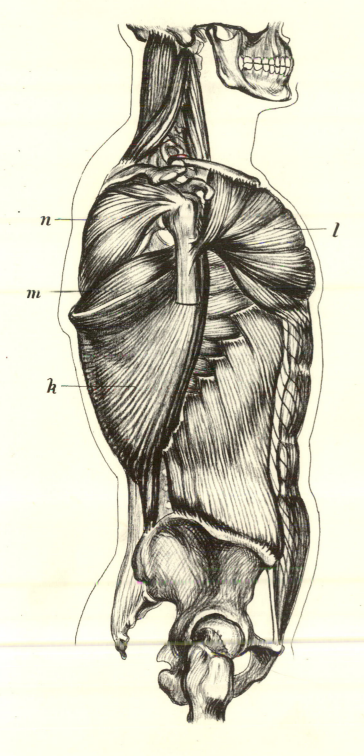

k. Latissimus dorsi
l. Pectoralis major
m. Teres major
n. Infraspinatus

q. Deltoideus
r. Trapezius
s. Sternocleidomastoideus

31

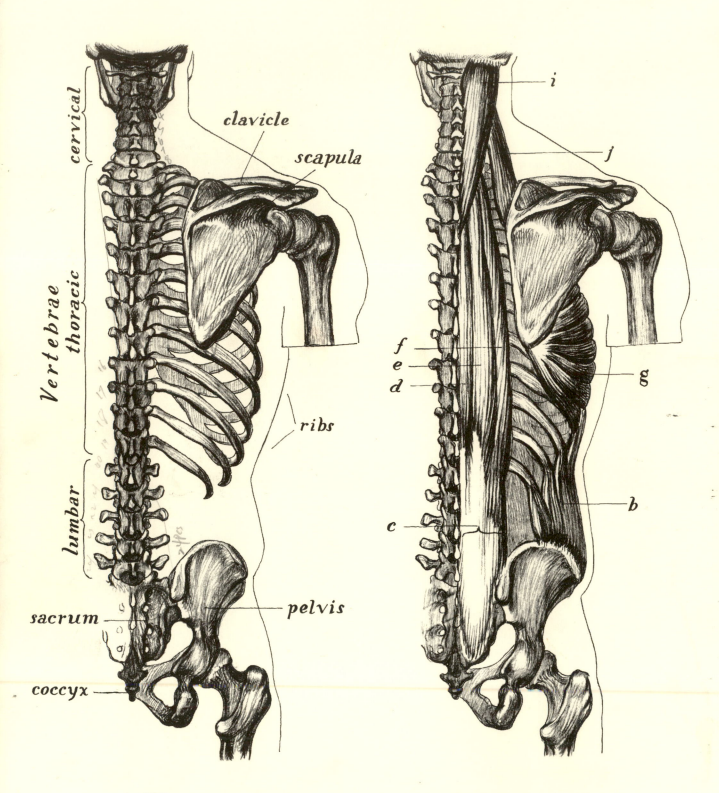

cervical

Vertebrae
thoracic

lumbar

clavicle

scapula

ribs

sacrum

pelvis

coccyx

i

j

f
e
d

g

c

b

b. Obliquus externus abdominis
c. Sacrospinalis (divides above into three muscles:
 d, *e*, and *f*)
d. Spinalis dorsi
e. Longissimus dorsi

f. Iliocostalis
g. Serratus anterior
i. Splenius capitis
j. Levator scapulae

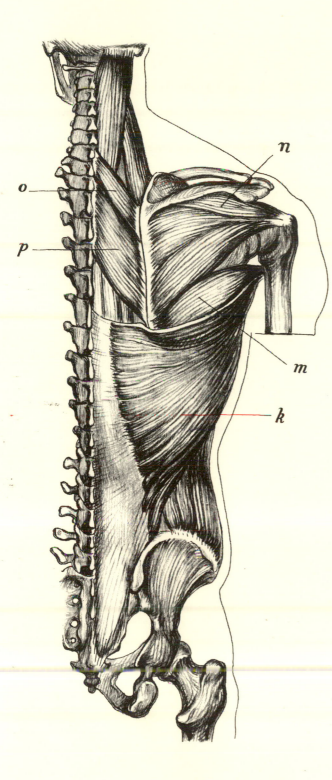

k. Latissimus dorsi
m. Teres major
n. Infraspinatus
o. Rhomboideus minor

p. Rhomboideus major
q. Deltoideus
r. Trapezius
s. Sternocleidomastoideus

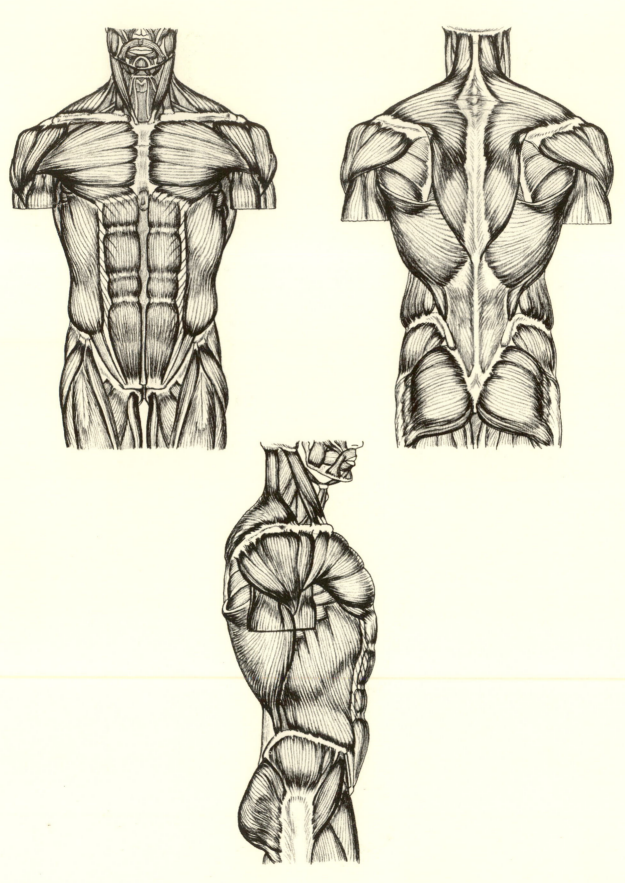

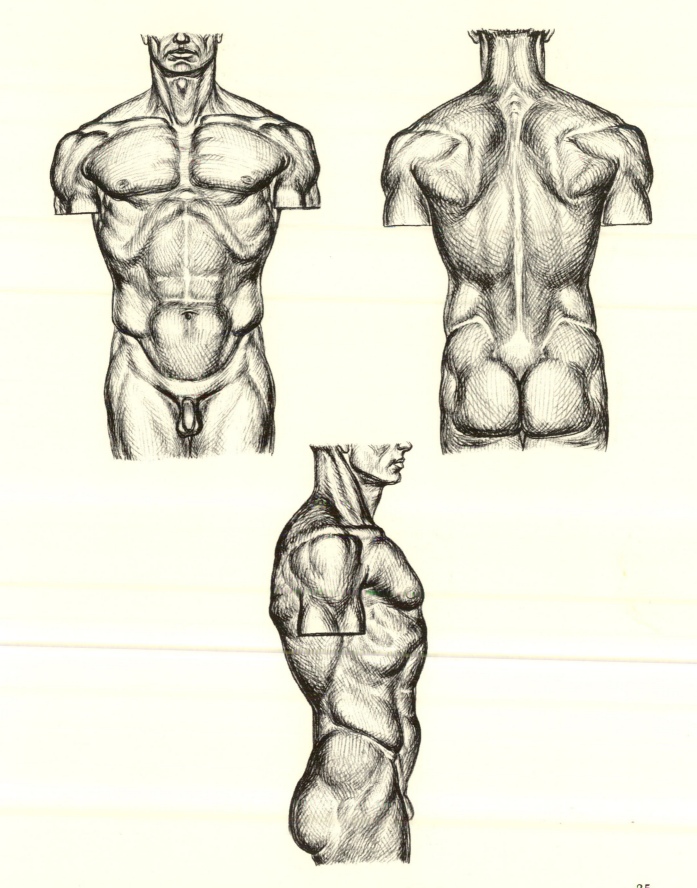

THE MOVEMENTS OF THE WAIST

The waist is capable of motion in every direction: flexion (bending forward), extension (bending backward), lateral motion (inclining the thorax to the side), and rotation (twisting of the thorax on the axis of the spine). Rotation, a restricted action, is not illustrated.

 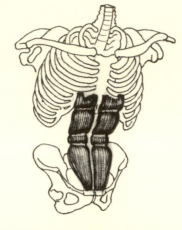 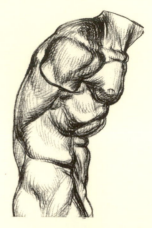

FLEXION. Rectus abdominis.

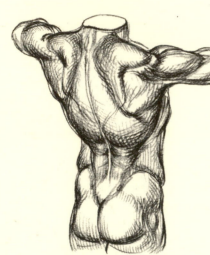 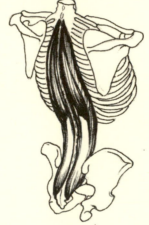 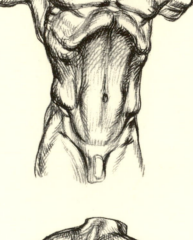

EXTENSION. Sacrospinalis.

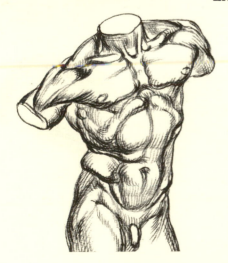 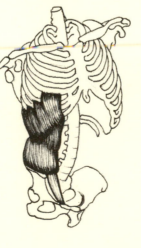 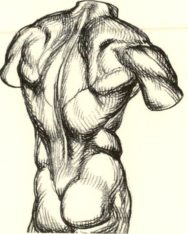

LATERAL MOTION. Obliquus externus abdominis.

THE ARM

The arm itself is the most mobile structure of the body, and its range of motion and utility are still further increased by the movements of the shoulder girdle, the hand, and the fingers.

THE BONES OF THE ARM

The bones of the arm are slender compared to the leg bones because they do not serve as supports for the body. Their joints are designed to accomplish the widest possible range of action. At the shoulder there is a ball-and-socket joint; at the elbow a hinge allowing the forearm to move forward; and at the wrist another hinge joint. If the arm hangs with the palm directed inward toward the leg, the hinge at the wrist operates in a direction at right angles to the action at the elbow. The usefulness of the hand is increased by the rotation of one of the forearm bones, allowing the hand to be twisted outward until the palm faces forward, and also inward through an arc of 180 degrees until the palm faces backward. This motion can be increased an additional 90 degrees by rotation of the arm inward at the shoulder joint until the palm faces to the outside away from the leg. The arm connects to the trunk by the shoulder girdle, which is itself movable. This complex system of joints produces an immensely varied combination of movements.

THE BONE OF THE UPPER ARM, the *humerus,* has, at its upper extremity, a hemispherical articular surface which fits into a shallow hollow on the outer corner of the shoulder blade. The shallowness of this socket and the comparative looseness of the ligaments joining the bones permit great mobility in the joint. At its lower extremity the shaft flattens and widens and terminates in two articular surfaces placed side by side, actually giving the appearance of one piece of a hinge. The outer articular surface is a rounded form; the inner one resembles an inverted saddle. Just above these articular surfaces, projecting to the sides, are the two prominences, the *epicondyles,* from which arise the two large groups of muscles of the forearm. The inner epicondyle projects farther to give greater leverage to the powerful flexors of the wrist.

THE BONES OF THE FOREARM are the ulna and the radius. The *ulna* connects to the upper arm in a true hinge joint; the radius, though articulated with the upper arm, also rotates around the ulna. Near

the upper end of the ulna, on its front surface, is a smooth area resembling the letter C which articulates with the saddle-shaped surface of the upper arm bone, allowing motion forward and back only. Projecting above this joint and to the rear is the large prominence of the *olecranon process*, the tip of the elbow. It is this prominence extending above the joint which prevents the forearm from bending too far backward. Below this joint, the shaft of the ulna tapers and terminates in a ball-like form, which shows prominently just above the wrist on the outside and rear of the arm. The entire length of the ulna is superficial at the back of the arm, showing on the surface form as a furrow dividing the inner and outer muscle groups of the forearm. The ulna is analogous to the shin bone in the lower leg, which is likewise superficial; the olecranon process analogous to the kneecap, being similar in shape and in placement above the joint.

The *radius,* the second bone of the forearm, articulates with the ulna at two separate points and articulates with the upper arm as well. The end of the radius at the elbow joint is situated beneath the upper arm bone and to the outside and somewhat to the front of the ulna. At this extremity the bone expands into a thick disc-shaped form; its hollowed upper surface is in contact with the rounded articular surface of the upper arm bone and its thick edge fits into a groove at the side of the ulna. The shaft of the radius as it extends downward twists so that its lower extremity is situated in front of the ulna. Here it again articulates with the ulna. The lower portion of the radius is considerably expanded to provide on its underneath surface an oval hollow for the wrist articulation.

Movement at the elbow joint is effected by the ulna moving in relation to the upper arm, the ulna carrying the radius with it. The twisting of the forearm is effected by the radius rotating around the ulna. In the latter motion, the upper extremity of the radius swivels but remains in its relative position to the ulna, while the lower extremity rotates around the ulna as an axis. This motion of the forearm is called pronation when the palm is turned inward and toward the back, and supination when the palm is turned outward and toward the front.

THE MUSCLES OF THE ARM

These muscles can be divided into four main groups, two in the upper arm to operate the hinge joint of the elbow, and two in the forearm to operate the hinge joint of the wrist. As the arm hangs at the side with the palm facing inward (as in the plates), the upper arm groups are placed front and back, while the two forearm groups are side to side because the hinge of the wrist operates at right angles to the elbow action. To these four main groups are added two small muscles, associated with the outside forearm group, which have an action on the thumb alone. Finally, the shoulder muscle, or deltoideus, also is added, because it is here considered as an arm muscle. (See page 26 for its description as a muscle of the shoulder girdle.)

THE MUSCLES OF THE UPPER ARM comprise a front group and a back group. In the *front group* are the brachialis, biceps brachii, and coracobrachialis. The first two of these connect to the forearm and operate the elbow hinge. The *brachialis* arises from the shaft of the upper arm bone, forming a broad and rather flat body. As the muscle passes to the forearm in front of the elbow joint, it both narrows and thickens, and it is inserted into the front surface of the ulna. Its influence on the surface form is usually not important. With the biceps, it bends the elbow. The *biceps brachii* arises in two heads from two sepa-

38

rate points on the shoulder blade. The long tendon leading to the outer head of the muscle arises from above the articular hollow into which the arm bone fits, passing over the head of the arm bone. The origin of the inner head of the muscle is at the coracoid process, the part of the shoulder blade which projects to the front of the shoulder joint. The two heads merge to form a straight thick body superimposed upon the brachialis, terminating in a long tendon which is inserted into the forearm at the radius. The biceps brachii and brachialis together raise the forearm by flexing the elbow. The biceps also has the secondary functions of twisting the forearm because of its insertion into the radius, and of raising and lowering the upper arm because of its two connections with the shoulder blade. The *coracobrachialis* is a small muscle seen in the armpit only when the arm is raised. It arises from the coracoid process of the shoulder blade and is inserted into the upper arm bone. Its action is on the shoulder joint to bring the arm toward the body. According to its function and connections, it can also be considered as one of that group of shoulder girdle muscles which pass from girdle to arm.

The *back group of muscles of the upper arm* is comprised of the triceps brachii and anconaeus, both of which connect to the forearm and operate the elbow hinge. The *triceps brachii* arises in three separate heads: the outer head arises from the upper portion of the shaft of the arm bone; the inner head arises from the lower two-thirds of the shaft; the center head arises from the edge of the shoulder blade. They end in a common tendon of insertion which connects to the forearm at the tip of the elbow. In a relaxed state the heads of the triceps are not often individually distinguished but appear as a single mass thicker at the middle than at either end. However, under tension, the upper portion of the outer head particularly is marked and the shape of the tendon shown as a depressed area. The triceps extends the forearm, placing it in line with the upper arm. The *anconaeus* is a small muscle just below the elbow. It can be considered as an extension of the triceps because some of its fibers merge with those of the lower portion of the outer head of the triceps. It arises from the outer epicondyle of the humerus, is directed downward and backward, and is inserted into the ulna. When the arm is fully extended, the muscle is most noticeable, appearing as a small pad adjacent to the tip of the elbow. It assists the action of the triceps.

In addition, the *deltoideus*, a muscle of the shoulder girdle, is also a muscle of the upper arm. It is a heavy triangular muscle covering the shoulder joint, arising from the outer third of the collarbone, from the acromion process, and from the spine of the shoulder blade. The fibers pass downward over the head of the upper arm bone and are inserted into the outside of the bone. The surface shape of the muscle is influenced at the side and front by the head of the arm bone, while the muscle itself is thickest at a point below that head. If the central fibers are contracted, the arm will be raised from the side, an action in opposition to the coracobrachialis. The front and back fibers acting independently help to bring the arm forward and back respectively.

THE MUSCLES OF THE FOREARM have a complex set of functions to perform; the twisting of the forearm, the movements of the wrist, and most of the movements of the fingers. The thirteen muscles of the forearm which are illustrated in the plates are divided into two main groups, inside and outside, and one small subsidiary group which operates the thumb.

The *outside group of the forearm* consists of six muscles, four of which arise from the outer epicondyle of the humerus and two from the bony ridge immediately above it. Those arising from the epicondyle itself are the extensor carpi ulnaris, extensor digiti quinti proprius, extensor digitorum communis, and extensor carpi radialis brevis. These four muscles are placed side by side and all arise from a

common tendon. All are slender in body and each terminates separately in a long tendon. The muscle situated at the back of the arm, adjacent to the ulna, is the *extensor carpi ulnaris*. Its tendon of insertion passes behind the bony prominence at the base of the ulna and is inserted into the metacarpal bone of the little finger. It assists in extending the hand at the wrist joint, and also, operating with the back muscle of the inside group, it bends the hand backward toward the ulna in ulnar flexion.

The next two muscles forward are, in order, the *extensor digiti quinti proprius* and *extensor digitorum communis*. They are so closely allied that they are sometimes considered as one muscle. The tendons from the two muscles merge at the wrist but divide as they cross the outer surface of the hand to be inserted into each of the four fingers. These muscles extend the hand at the wrist joint and the fingers as well. The fourth muscle of the group, adjacent to the radius, the *extensor carpi radialis brevis,* has its tendon inserted into the metacarpal bone of the middle finger. It is primarily an extensor of the hand; but, acting with the two muscles leading to the thumb and the front muscle of the inside group, it bends the hand forward toward the radius in radial flexion. As we can exert little strength in extending the hand and fingers, the muscles of this extensor group are not so powerful or massive as those of its counterpart, the flexor group on the inside of the forearm. Usually these muscles show as a single simple form; but, on a lean model, moving the fingers will show the muscular divisions in the arm as well as the tendons on the back of the hand.

The two remaining muscles of this outside group of the forearm arise from the ridge above the epicondyle of the upper arm bone. The *extensor carpi radialis longus* arises from immediately above the epicondyle. The muscle passes downward. Then it twists from the outer to the front surface of the arm and terminates in a long tendon which is inserted into the metacarpal bone of the index finger. It assists in extending the hand. The *brachioradialis* arises higher on the ridge above the epicondyle. Its body twists with and is adjacent to the extensor carpi radialis longus, and it is inserted into the shaft of the radius on its inner side. Its principal action is to turn the palm forward by rotating the radius. These two muscles form a single mass which arises from between the front and back groups of muscles of the upper arm and has its greatest thickness as it passes the elbow joint. Hence its main bulk is above and separated from the muscles that arise from the epicondyle itself. As it passes downward, this mass tapers and merges with the general form of the forearm. Because these muscles are thickest at the joint itself, when the elbow is bent they fold on themselves and tend to be squeezed out to the side.

The two small muscles operating the thumb, which are shown in the plates, are the abductor pollicis longus above and the extensor pollicis brevis below. Both arise deep within the forearm and pass obliquely downward, twisting around the front and lower part of the forearm, paralleling the directions of the two muscles which twist around the elbow. The *abductor pollicis longus* arises from the shafts of both the ulna and the radius, and its tendon is inserted into the metacarpal bone of the thumb. Its action moves the thumb in the plane of the hand away from the palm. The *extensor pollicis brevis* arises from the shaft of the radius and is inserted into the first phalanx of the thumb. Its action is to extend or raise the thumb. These two small muscles usually have only slight influence on the surface form. A third muscle, the *extensor pollicis longus,* assists in extending the thumb. It arises from the ulna and its muscular body is deep within the arm. The tendon, however, comes to the surface and shows prominently as it passes diagonally across the wrist to the thumb to be inserted into the terminal phalanx. Because this muscle is nowhere superficial, only its tendon is shown in the plates.

The *inside group of the forearm* consists of five muscles; one deep muscle, and four superficial muscles arising from the inner epicondyle of the upper arm bone. The deep muscle is the *flexor digitorum sublimis.* It arises from three separate origins, from the epicondyle of the upper arm, from the ulna, and from the radius. From its surface fibers two tendons extend to the phalanges of the middle and ring fingers, and from its inner fibers two tendons extend to the phalanges of the index and little fingers. (In the arm plates, these last two tendons are not shown.) Although this is the largest of the muscles of the inside group, accounting for much of the bulk of the inner side of the forearm, it only indirectly influences the surface form because it lies beneath the other muscles of the inside group. It is the principal flexor of the fingers, closing the hand. Its extensive attachments at the points of origin and its thickness give strength to the grasping action of the hand.

The four superficial muscles of the inside group, which all arise from the inner epicondyle of the upper arm, are the flexor carpi ulnaris, palmaris longus, flexor carpi radialis, and pronator teres. The *flexor carpi ulnaris* is situated at the back of this group adjacent to the ulna. Its body is thick and long, with some of its fibers extending almost to the wrist. Its tendon is thick and prominent and is inserted into the so-called heel of the hand, the carpal bone which projects prominently at the rear and inner surface of the palm. Primarily it is a flexor of the wrist; but, acting with the back muscle of the outside group, it bends the hand backward, toward the ulna, in ulnar flexion. The next muscle forward is the *palmaris longus.* Its muscular fibers are short but its tendon is long, passing across the wrist into the palm, where it fans out to be inserted into a fibrous aponeurotic sheath covering the muscles of the palm. (This aponeurosis has been omitted from the plates.) The tendon is one of the two tendons which show prominently on the inside surface of the arm above the wrist. The muscle flexes the wrist.

The next muscle in order forward is the *flexor carpi radialis,* extending downward parallel to the two muscles mentioned previously. Its tendon is the second of the two prominent tendons at the wrist and is inserted into the metacarpal bone of the index finger. It is a flexor of the wrist, but it also acts with the long muscle at the front of the outside extensor group and with the two muscles of the thumb to bend the hand forward toward the radius, in radial flexion.

The fourth of the superficial muscles of the inside group, situated farthest to the front, is the *pronator teres.* It arises from the common tendon at the epicondyle but, unlike the other muscles of the group, is directed diagonally forward. It is superficial for a short distance, then passes beneath the outside group of muscles and is inserted into the shaft of the radius, deep within the body of the arm. Its function is to pronate the hand, that is, to twist the arm so that the palm faces backward. These four superficial muscles of the inside group are seldom seen separately on the surface form but combine to give the appearance of a single mass. However, this muscular form is frequently divided into two shapes by a diagonal furrow, crossing the arm below the elbow. This furrow is formed by the *lacertus fibrosus* (see pages 45 and 47), an extension of the biceps tendon which merges with the fascia covering the arm, producing a constricting effect on the muscles.

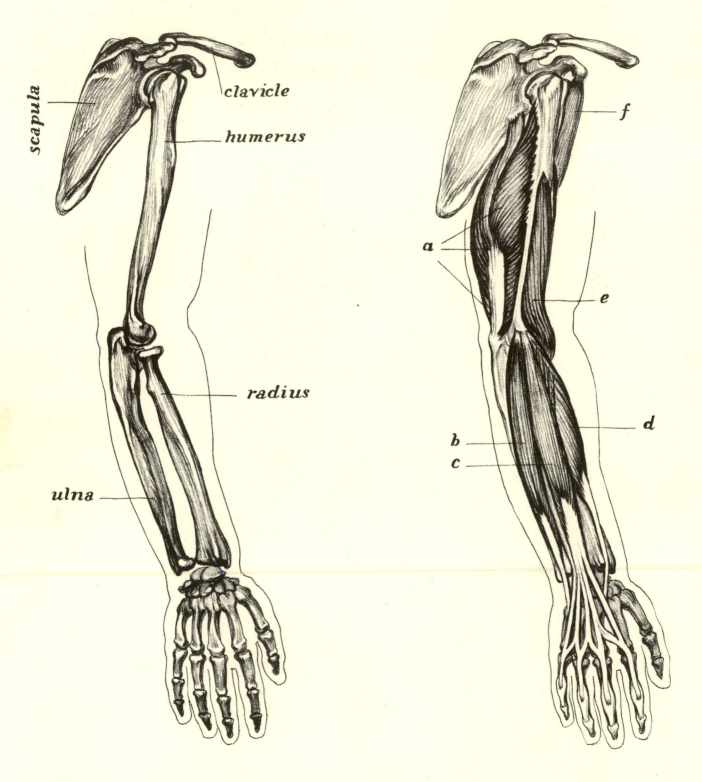

42

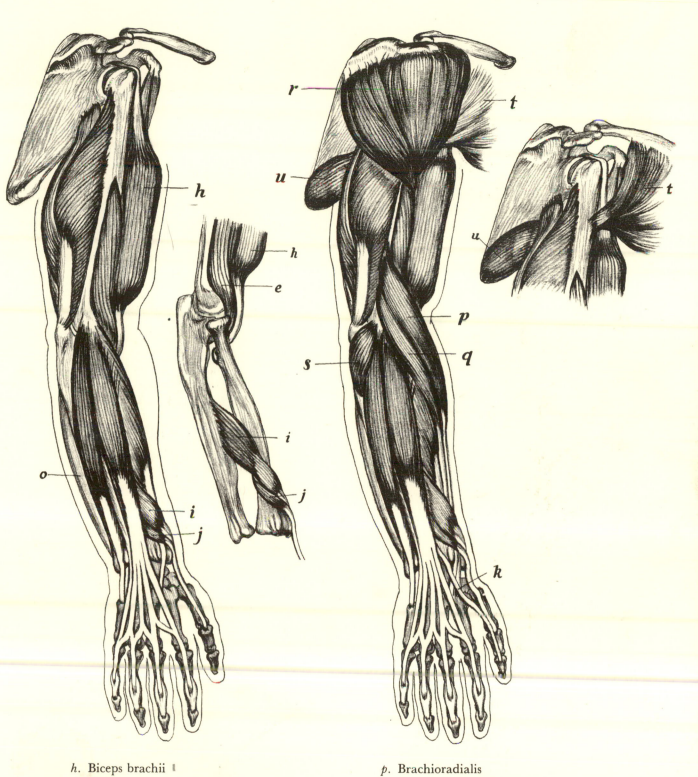

h. Biceps brachii
i. Abductor pollicis longus
j. Extensor pollicis brevis
o. Flexor carpi ulnaris
e. Brachialis
k. Tendon from extensor pollicis longus (a deep muscle not shown)

p. Brachioradialis
q. Extensor carpi radialis longus
r. Deltoideus
s. Anconaeus
t. Pectoralis major (see trunk plates)
u. Teres major (see trunk plates)

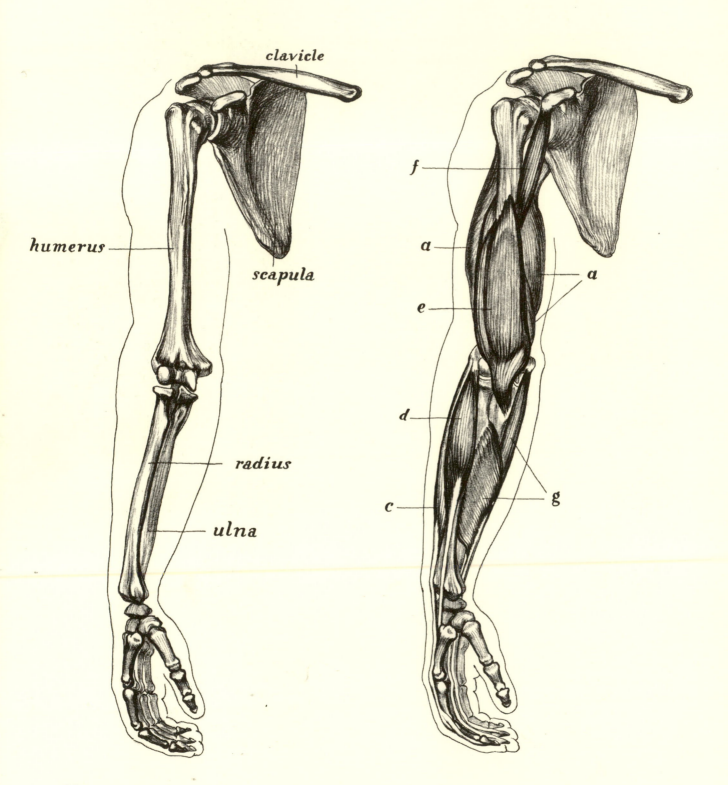

a. Triceps brachii
c. Extensor digitorum communis
d. Extensor carpi radialis brevis

e. Brachialis
f. Coracobrachialis
g. Flexor digitorum sublimis

clavicle

humerus

scapula

radius

ulna

f

a

a

e

d

c

g

44

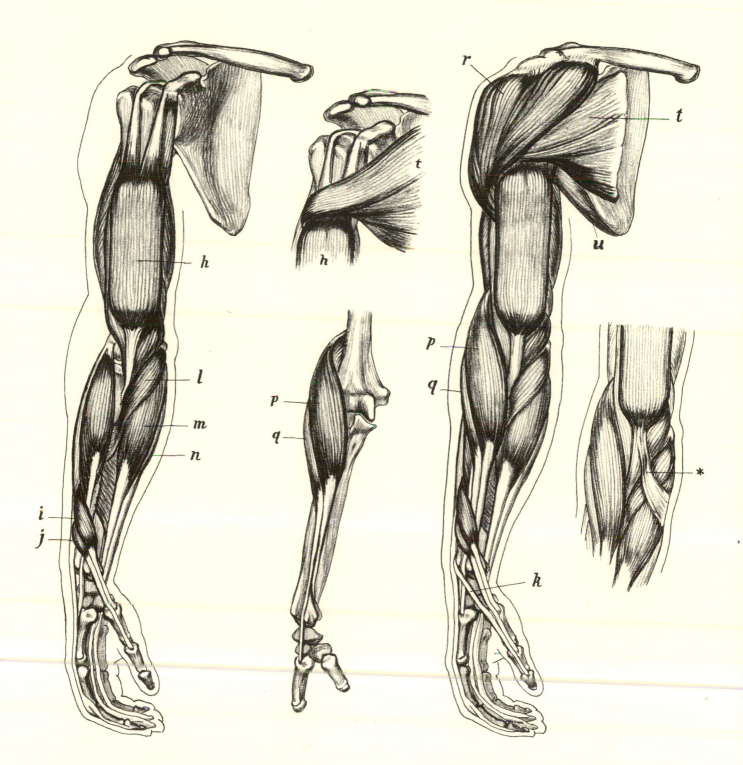

h. Biceps brachii
i. Abductor pollicis longus
j. Extensor pollicis brevis
k. Tendon from extensor pollicis longus (a deep muscle not shown)
l. Pronator teres
m. Flexor carpi radialis

n. Palmaris longus
p. Brachioradialis
q. Extensor carpi radialis longus
r. Deltoideus
t. Pectoralis major (see trunk plates)
u. Teres major (see trunk plates)
* Lacertus fibrosus

a. Triceps brachii
d. Extensor carpi radialis brevis
e. Brachialis
f. Coracobrachialis

g. Flexor digitorum sublimis (from the deep fibers of this muscle two other tendons, not shown, extend to the index and little fingers)

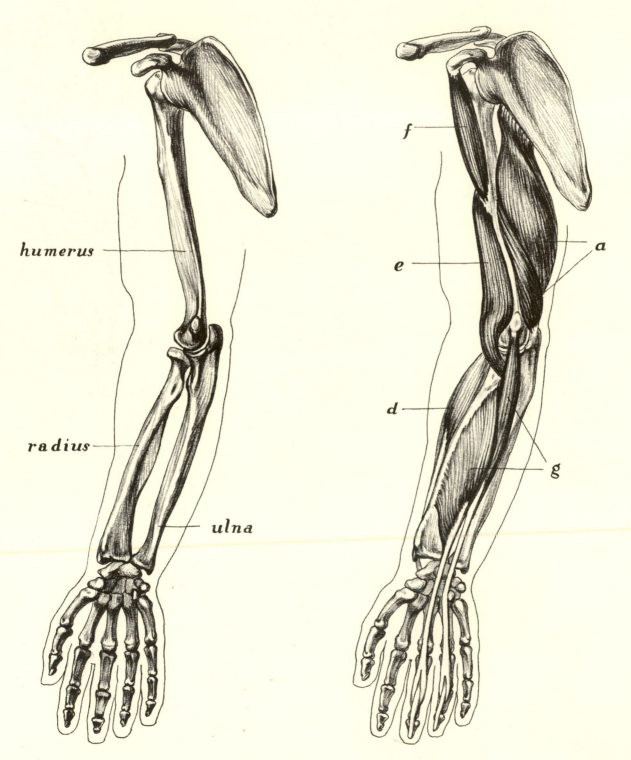

humerus

radius

ulna

f

e

a

d

g

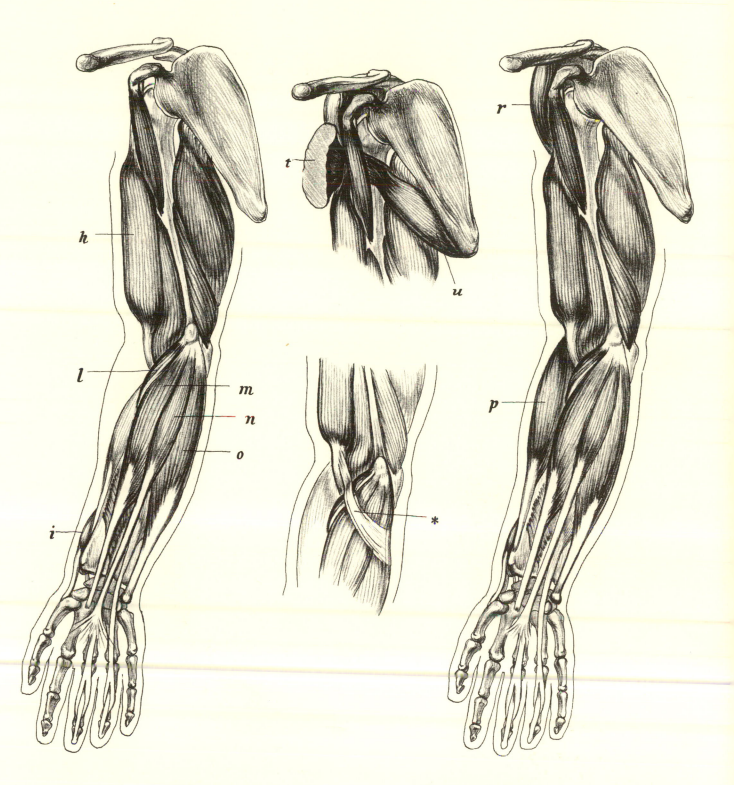

h. Biceps brachii
i. Abductor pollicis longus
l. Pronator teres
m. Flexor carpi radialis
n. Palmaris longus (tendon flares into an aponeurosis, not shown, which extends to the base of each finger)

o. Flexor carpi ulnaris
p. Brachioradialis
r. Deltoideus
t. Pectoralis major (see trunk plates)
u. Teres major (see trunk plates)
* Lacertus fibrosus

a. Triceps brachii
b. Extensor carpi ulnaris
c. Extensor digitorum communis and extensor
 digiti quinti proprius
g. Flexor digitorum sublimis

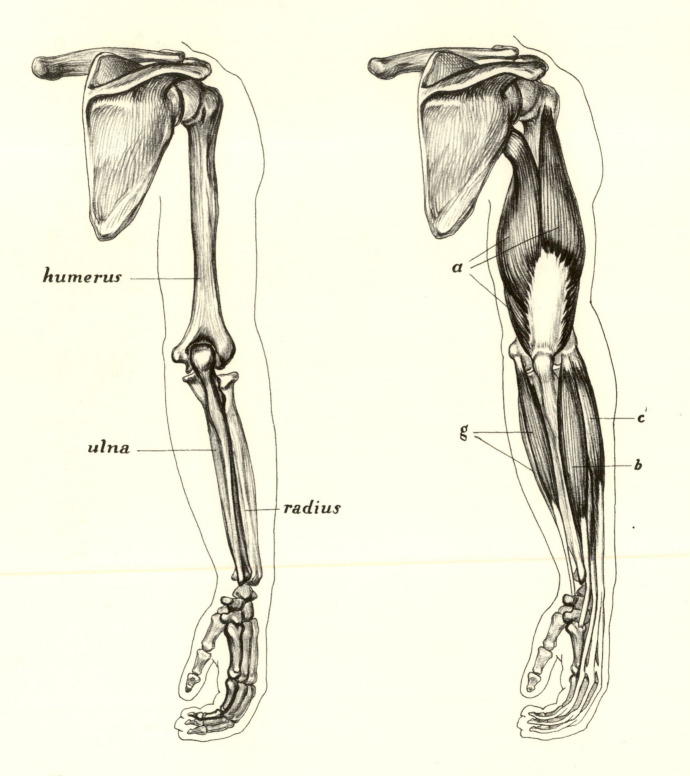

humerus

ulna

radius

a

g

c

b

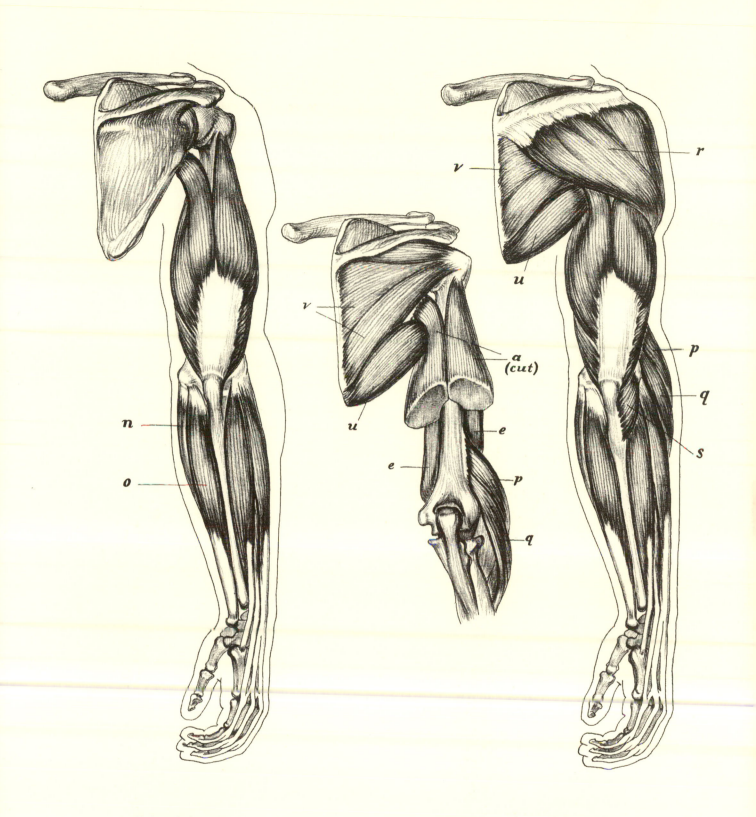

n. Palmaris longus
o. Flexor carpi ulnaris
a. Triceps brachii
e. Brachialis
p. Brachioradialis

q. Extensor carpi radialis longus
r. Deltoideus
s. Anconaeus
u. Teres major (see trunk plates)
v. Infraspinatus (see trunk plates)

49

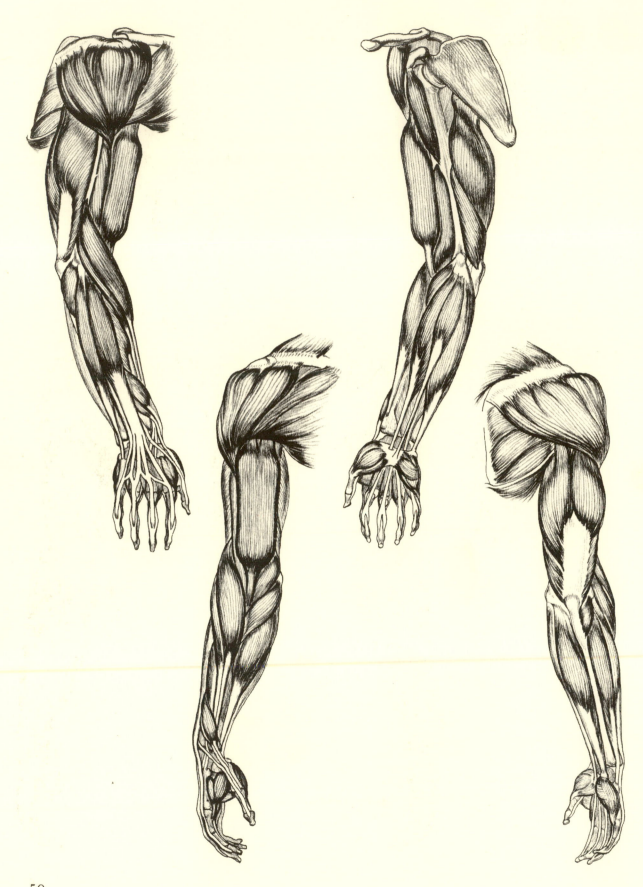

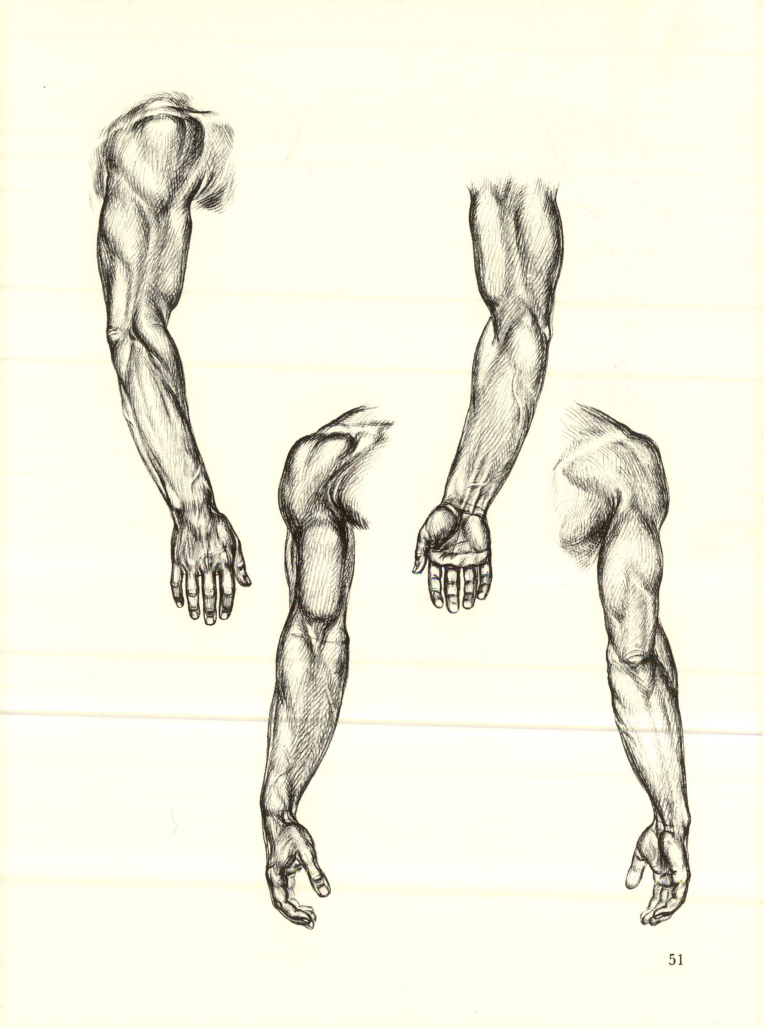

THE MOVEMENTS OF THE SHOULDER

The shoulder is a ball-and-socket joint capable of motion in all directions and also of rotation of the arm around its axis. The action of the arm forward, back, and upward is considerably increased by the movements possible in the bones of the shoulder girdle.

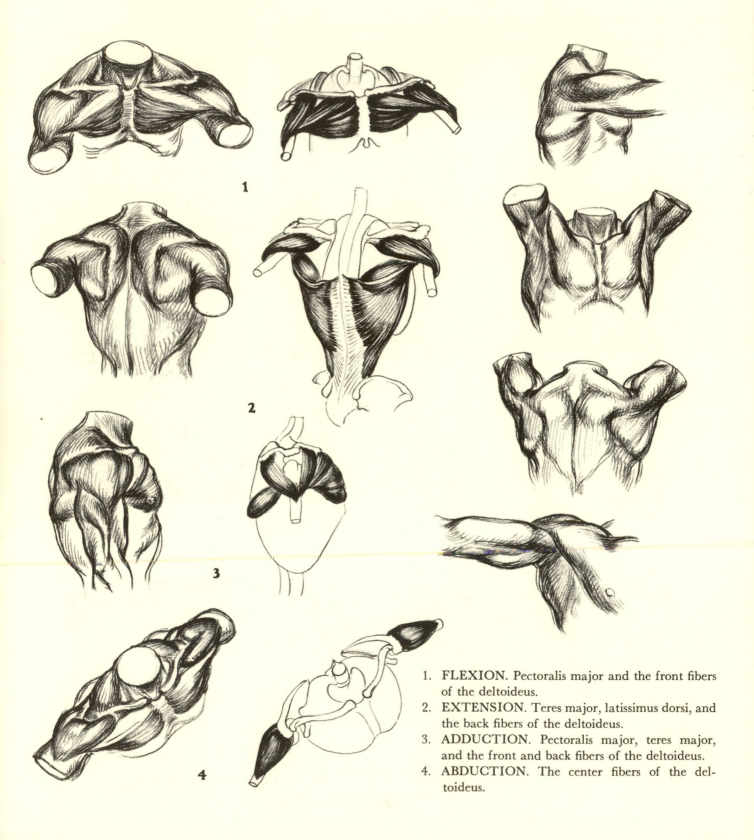

1. **FLEXION.** Pectoralis major and the front fibers of the deltoideus.
2. **EXTENSION.** Teres major, latissimus dorsi, and the back fibers of the deltoideus.
3. **ADDUCTION.** Pectoralis major, teres major, and the front and back fibers of the deltoideus.
4. **ABDUCTION.** The center fibers of the deltoideus.

THE MOVEMENTS OF THE ELBOW

The elbow is a hinge joint, moving the forearm forward (flexion) and backward (extension). The rotation of the forearm (supination and pronation) is caused by the radius rotating around the ulna and is therefore not a function of the elbow hinge.

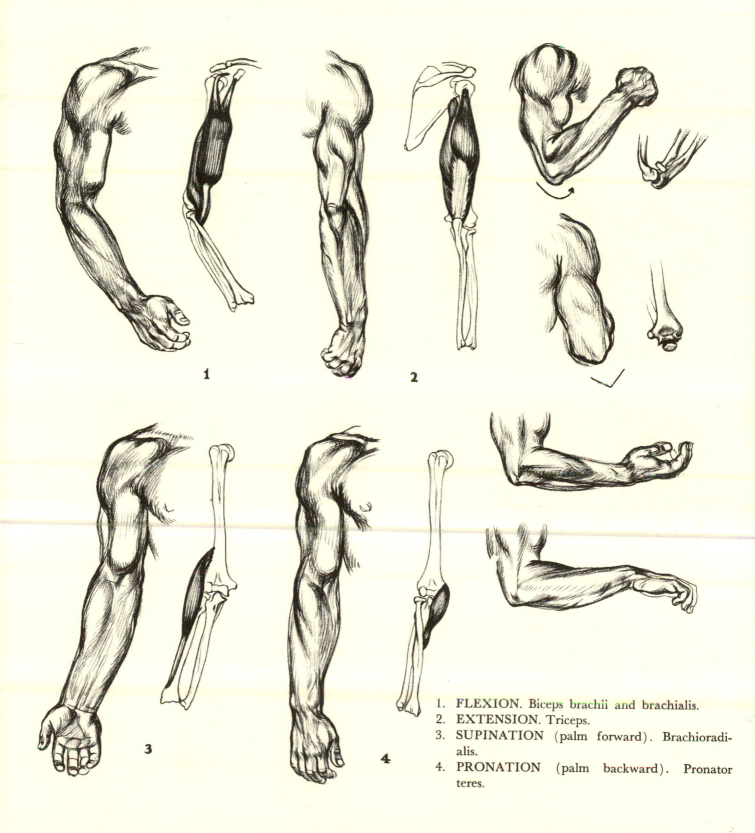

1. FLEXION. Biceps brachii and brachialis.
2. EXTENSION. Triceps.
3. SUPINATION (palm forward). Brachioradialis.
4. PRONATION (palm backward). Pronator teres.

THE MOVEMENTS OF THE WRIST

The wrist is a variant of a hinge joint, permitting all movements except rotation. Flexion and extension are the most free, giving the effect of a true hinge joint. The actions of ulnar and radial flexion are considerably restricted in comparison.

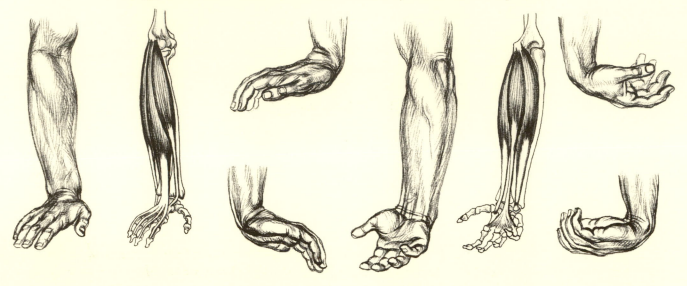

EXTENSION. Extensor carpi radialis brevis, extensor digitorum communis, and extensor carpi ulnaris.

FLEXION. Flexor carpi radialis, palmaris longus, and flexor carpi ulnaris.

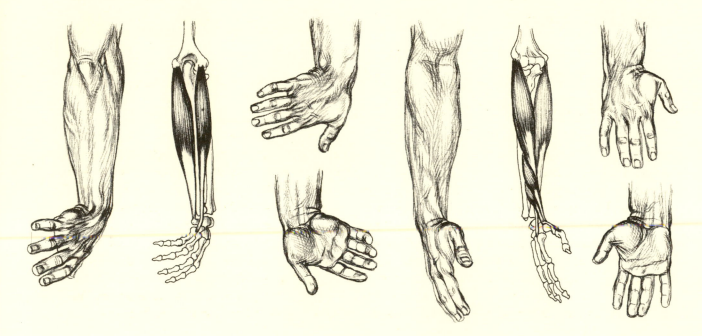

ULNAR FLEXION. Extensor carpi ulnaris, and flexor carpi ulnaris.

RADIAL FLEXION. Abductor pollicis longus, extensor pollicis brevis, extensor carpi radialis brevis, and flexor carpi radialis.

THE HAND

The hand is one of the most complex structures of the human body since it is formed to provide both great strength and great mobility. Because the component parts of the hand are small and are not usually shown on the surface, considerable study is required to draw the hand with understanding. The bony and muscular structure is close beneath the skin on the outer surface, or back of the hand, but on the inner surface the forms are hidden beneath a thick layer of protective tissue. This fibrous padding is incorporated within the fascia; its forms are therefore independent of structure, though its deep creases are indicative of the joints.

THE BONES OF THE HAND

The bones of the hand are divided into three groups, the carpal bones at the wrist joint, the metacarpal bones, and the phalanges of the fingers.

There are eight *carpal bones*, arranged in two transverse rows of four bones each. These small, irregularly shaped bones fit closely together to form an arch which curves toward the outside surface of the wrist. The enclosure formed by this bony arch is bridged across by a strong ligament, the *transverse carpal ligament*, forming a tunnel through which the tendons of the flexor group of the forearm pass to the hand. The top surfaces of three of the upper row of carpal bones together form a smooth elongated convex surface which articulates with the hollow groove on the underside of the radius. The shape of this articulation allows extensive movement of the wrist inward and outward, but only restricted movement forward and back. The fourth bone of the top row projects to the inside of the wrist and forms the prominence called the heel of the hand. These four bones of the top row are rigidly held together by ligaments and can be moved in relation to one another only by external pressure. There is, however, limited movement possible between this top row and the rigid lower row of four carpal bones beneath.

The five *metacarpal bones*, the bones of the hand proper, are joined to the arch of the four lower carpal bones, and, in consequence, are also arranged in an arch. The four metacarpal bones which ex-

tend to the four fingers are connected to the carpal arch by joints that are rigid for the bones leading to the index and middle fingers and only slightly movable for the bones leading to the ring and little fingers. Their free ends are held in relation to one another by a system of transverse ligaments. The metacarpal of the thumb, in contrast, is articulated to the carpal arch by a joint capable of very free motion in all directions. The motions at this joint are controlled by muscles which can bring the thumb into the plane of the palm or into opposition to each of the fingers.

Each metacarpal bone is joined to one of the fingers by means of a smooth rounded surface on the metacarpal bone inserted into a hollow on the first phalanx of the finger. These joints hinge the fingers to the hand, permitting the flexion of the fingers in grasping and the opposite motion of extension, and (except at the thumb) allowing lateral motion in order to spread the fingers.

The *phalanges* are fourteen in number, three for each finger and two for the thumb. The joints between them are true hinges: each phalanx terminates in two rounded articular surfaces fitting into two corresponding hollows in its connecting phalanx, thus precluding any lateral motion. When the fingers are bent, the two articular prominences can easily be seen. The terminal phalanx in each case ends in a flattened form to which the nail is attached.

THE MUSCLES OF THE HAND

The muscles of the hand, shown in the plates, control the movements of the metacarpal bone of the thumb and the spreading and closing together of the four fingers. Some of them likewise assist in flexing and extending the fingers and thumb, but these motions are primarily effected by the powerful muscles of the forearm connected to the fingers by their long tendons. The muscles of the hand which lie between the metacarpal bones of the four fingers do not show on the surface, but the remaining muscles combine to produce three prominent forms: two are situated between the metacarpal bones of the thumb and index finger, one on the back of the hand and the other on the palm; the third prominent form is on the palm at the heel of the hand.

Of the four *muscles operating the metacarpal bone of the thumb,* three are muscles of the palm, the opponens pollicis, abductor pollicis brevis, and adductor pollicis transversus. The *opponens pollicis* arises from the carpal bones and the transverse carpal ligament and is inserted into the metacarpal bone of the thumb. It draws the bone across the surface of the palm. The *abductor pollicis brevis* arises from the same sources and is inserted into the base of the first phalanx of the thumb; therefore it has only an indirect action on the metacarpal bone. It moves the metacarpal at right angles to the palm of the hand. The *adductor pollicis transversus* arises from the metacarpal bone of the middle finger and is inserted also into the base of the first phalanx of the thumb, moving the metacarpal of the thumb to the palm. These three muscles do not show individually, but help to form the muscular pad on the palm at the base of the thumb. The fourth muscle operating the metacarpal bone of the thumb is the *abductor pollicis longus,* a muscle of the forearm; its tendon is inserted into the base of the bone, moving it away from the palm.

The *muscles which spread and close together the fingers* are the interossei volares, interossei dorsales, and abductor digiti quinti. The *interossei volares* are deep muscles, not shown in the plates, situ-

56

ated between the metacarpal bones. They act to bring the four fingers together. The four *interossei dorsales,* overlying the volares, spread apart the index, middle, and ring fingers. The muscle between the metacarpal bones of the thumb and of the index finger is the largest of the interossei and shows prominently on the back of the hand. The *abductor digiti quinti* arises from the heel of the hand and is inserted into the base of the first phalanx of the little finger. It spreads the little finger.

The *flexors and extensors of the thumb* are four in number, only one of which is a muscle of the hand proper, the *flexor pollicis brevis.* This muscle arises from the carpal bones and from the transverse carpal ligament and is inserted into the first phalanx of the thumb. It forms a part of the muscular pad in the palm at the base of the thumb, and flexes the thumb. The other flexor of the thumb is a deep muscle of the forearm, the *flexor pollicis longus,* which is not shown in the arm plates and in the hand plates is indicated only by its tendon of insertion. The extensors of the thumb are both muscles of the forearm: the *extensor pollicis longus,* a deep muscle not shown in the arm plates, and the *extensor pollicis brevis.*

The principal *flexors and extensors of the four fingers* are muscles of the forearm. Flexion is accomplished by the *flexor digitorum sublimis,* the forearm muscle which has four tendons extending across the palm to the fingers. The following muscles of the hand assist the action: the *interossei dorsales, lumbricales,* and *flexor digiti quinti brevis.* The last-named muscle arises from carpal bones and the transverse carpal ligament and is inserted into the first phalanx of the little finger. Extension is accomplished by the *extensor digitorum communis* and *extensor digiti quinti proprius,* forearm muscles with tendons which cross the back of the hand and are inserted into the phalanges of the fingers. The action is assisted by the *interossei dorsales* and *lumbricales.* These last muscles have double insertions, into the phalanges for flexion and into the extensor tendons for extension.

The *palmaris brevis,* a very thin superficial muscle, arises from the transverse carpal ligament and is inserted into the skin of the hand. Its action is unimportant.

In its simplest terms, the form of the hand proper is a square shape with a movable triangular shape joined to one of its edges. The four fingers join to the square and the thumb to the triangle. The square form is slightly arched, conforming to the arch of the carpal and metacarpal bones; and, in consequence, the outer surfaces of the fingers and their nails lie in a curved plane similarly arched. Hence, when the fingers are bent, their tips tend to converge to a point. The movable triangular shape continues the curved character of the hand and therefore the thumb will also converge to the finger tips when it is bent.

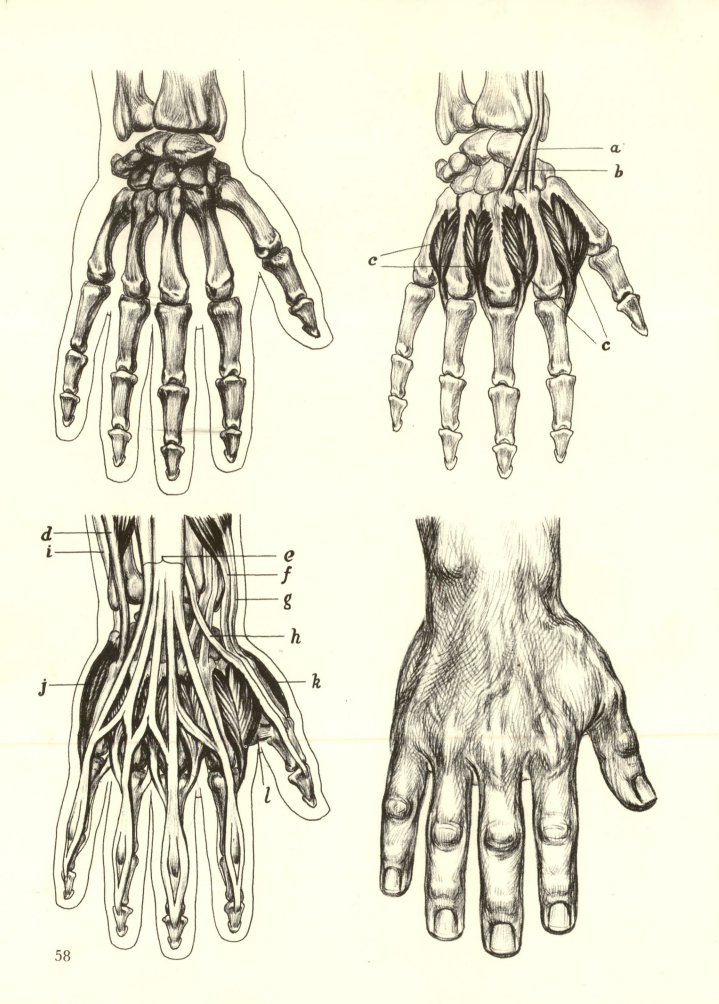

58

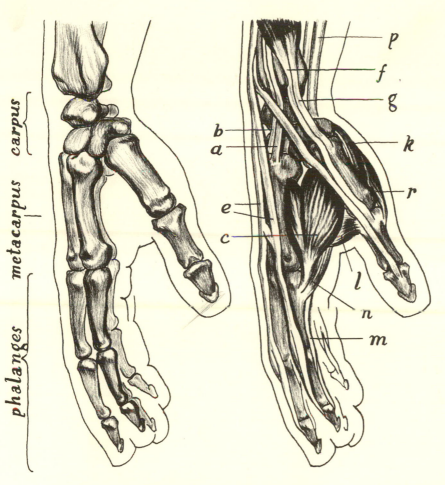

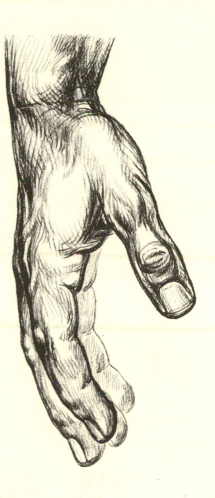

phalanges metacarpus carpus

- *a.* Tendon from extensor carpi radialis longus
- *b.* Tendon from extensor carpi radialis brevis
- *c.* Interossei dorsales
- *d.* Extensor carpi ulnaris
- *e.* Tendons from extensor digitorum communis and extensor digiti quinti proprius
- *f.* Extensor pollicis brevis
- *g.* Abductor pollicis longus
- *h.* Tendon from extensor pollicis longus (a deep muscle not shown in arm plates)

- *i.* Flexor carpi ulnaris
- *j.* Abductor digiti quinti
- *k.* Opponens pollicis
- *l.* Adductor pollicis transversus
- *m.* Tendons from flexor digitorum sublimis
- *n.* Lumbricales
- *p.* Flexor carpi radialis
- *r.* Abductor pollicis brevis

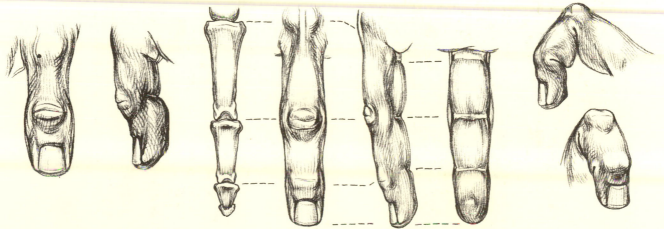

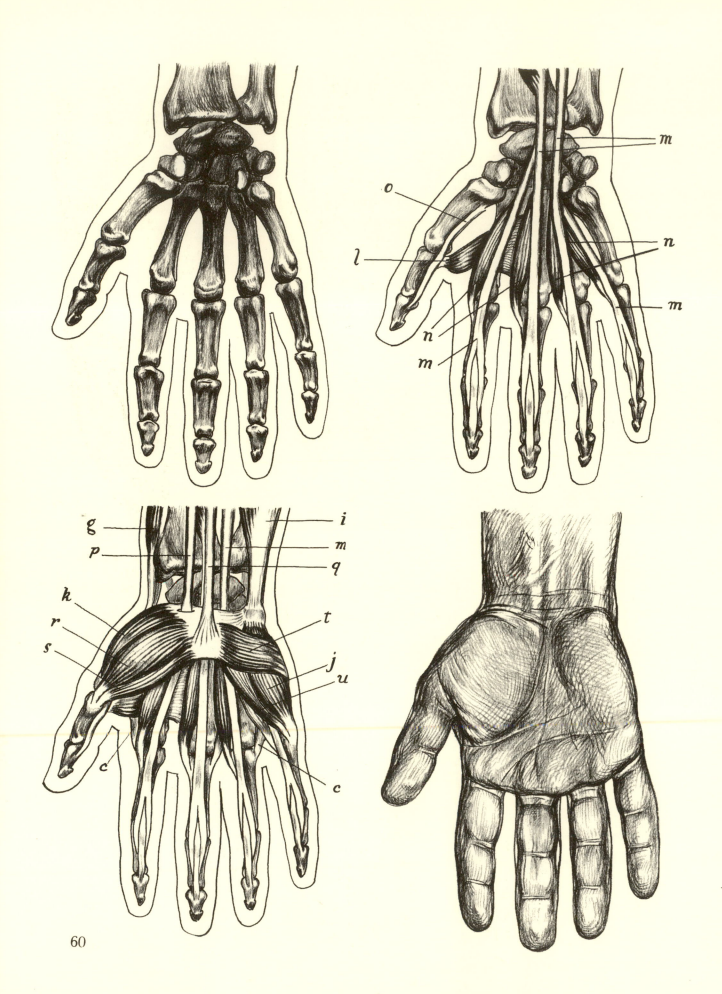

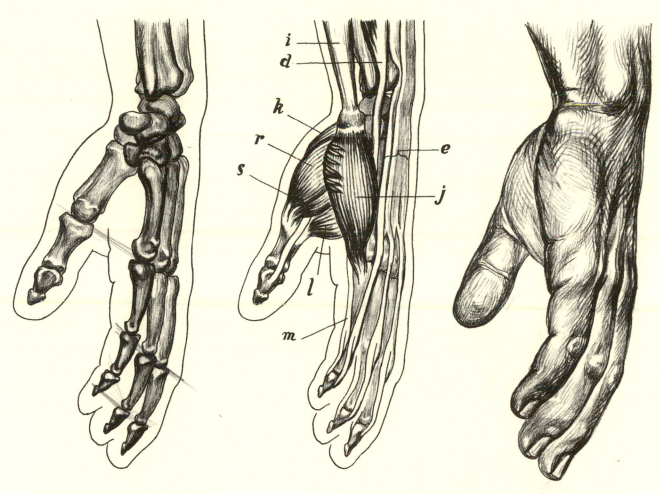

c. Interossei dorsales
d. Extensor carpi ulnaris
e. Tendons from extensor digitorum communis and extensor digiti quinti proprius
g. Abductor pollicis longus
i. Flexor carpi ulnaris
j. Abductor digiti quinti
k. Opponens pollicis
l. Adductor pollicis transversus
m. Tendons from flexor digitorum sublimis
n. Lumbricales

o. Tendon from flexor pollicis longus (a deep muscle of the forearm not shown in arm plates)
p. Flexor carpi radialis (inserted into base of the second metacarpal bone)
q. Palmaris longus (its tendon flares out into an aponeurosis which extends to the base of each finger [not shown])
r. Abductor pollicis brevis
s. Flexor pollicis brevis
t. Palmaris brevis (inserted into skin at back of hand)
u. Flexor digiti quinti brevis

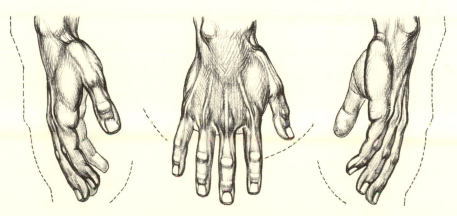

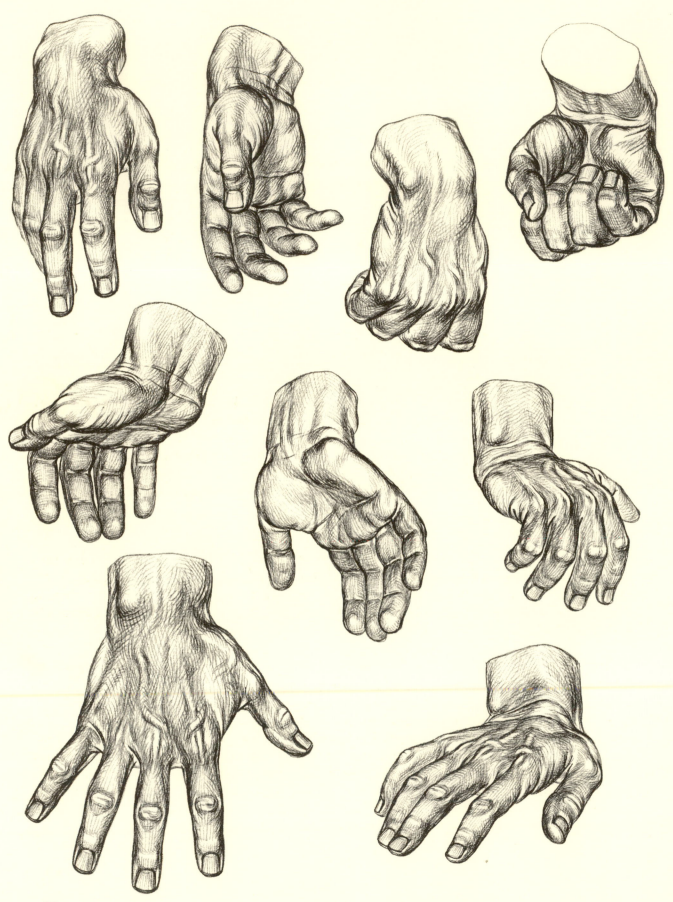

THE HIP AND LEG

There is a definite surface division of the body in the pelvic region, marked by the pubic bone in front, the iliac crest at the sides, and the sacrum behind. These bony prominences, or ridges, clearly separate the muscles of the trunk above from those of the hip and leg below. Because of this division, the muscles of the hip are described together with the leg muscles. The bones of the pelvic girdle are considered as a part of the hip as well as a part of the trunk.

THE BONES OF THE HIP

The two hip bones, the sacrum and the coccyx, comprise the pelvis, which has previously been described as part of the trunk on pages 23 and 24. As part of the trunk, these bones serve as a base for the spine, as support and protection for the organs of the abdominal cavity, and as attachments for trunk muscles. Considered here as a part of the hip and leg structure, they connect the legs to the trunk and serve as attachments for both hip and leg muscles.

The two *hip bones* are united in front by an immovable joint and united at the back by the sacrum. Together these three bones form a ring which transmits the weight of the trunk to the legs. The hip bone in infancy is actually three separate bones, the ilium, ischium, and pubis, which fuse together in the adult. The *ilium,* the upper portion of the hip bone, has an irregularly curved upper border called the *iliac crest,* which can usually be traced on the surface form along its entire extent. At the front this crest ends in a point of bone immediately beneath the skin, which can be seen bounding the abdomen at the side. The iliac crest at the back ends at a point which can be located on the surface form by the dimple on the back of each hip. The outer surface of the ilium beneath the crest and the sacrum afford attachments for the hip muscles.

Beneath the ilium, the *pubis* at the front and the *ischium,* situated behind the pubis, afford attachments for leg muscles. The lowest part of the hip bone is formed by a large ridge which extends from the underneath surface of the crest of the pubis in front; is directed obliquely downward, backward, and to the side; and terminates in the thick and rounded prominence of the ischium. This ridge is nowhere visible on the surface form, but it is important for its muscular attachments and because it supports the body in a sitting position.

On the lower outside surface of the hip bone is a deep articular cavity into which is inserted the head of the upper leg bone. This socket in the hip bone is deep, to give strength and stability, in comparison to the shallow socket at the shoulder joint. The *sacrum,* a triangular bone completing the pelvic girdle, projects to the rear and determines the slant of the hips. The *coccyx* is appended to the base of the sacrum, forming the lower tip of the spine.

The most noticeable difference between the male and female skeletons is in the size and shape of the pelvis. The female pelvis is both shallower and wider, which causes the trunk to be relatively longer and the abdomen and hips relatively wider than in the male. The female pelvis is set at a more oblique angle, and the sacrum, projecting farther to the rear, accentuates this obliquity.

THE BONES OF THE LEG

The bones of the leg correspond to the arm bones by having one bone in the upper limb and two in the lower, and also by their pattern of joints. At their connections to the trunk each has a ball-and-socket joint as well as two hinge joints below. However, the leg bones, developed for locomotion and support, differ primarily by being heavier and stronger and by having a more restricted action in the joints.

THE BONE OF THE UPPER LEG is the *femur,* or *thigh bone.* It articulates with the pelvis by a ball-and-socket joint capable of motion in every direction. However, the motion of the leg backward is checked by a very strong ligament crossing the front side of the joint. In the erect standing position, this hip joint is situated a little in advance of the body's center of gravity and the leg bone is bent only slightly backward in relation to the pelvis. In this position, the ligament locks the joint, holding the body erect with very little muscular effort. To move the leg backward to any extent, as in a long stride, because of this lock, it is necessary to tip the pelvis. The ball-shaped articular surface of the femur is at the end of a neck of bone projecting at an obtuse angle from the upper extremity of the shaft. This neck provides a lever necessary for the hip muscles to raise the leg to the side.

The bony prominence at the upper extremity of the shaft of the femur is not covered by muscle and lies close beneath the skin, influencing the surface form. The shaft is directed inward and terminates in an expanded shape, forming two *condyles,* or articular prominences. The under and back surfaces of these condyles of the femur are rounded to fit into two corresponding hollows on the upper surfaces of two condyles at the top end of the larger lower leg bone in order to form the knee joint. This joint, like the elbow, is a true hinge. It allows the lower leg to bend only backward, whereas the elbow hinge allows the forearm to bend only forward. The lower leg cannot bend forward because of a ligament across the back of the joint which locks it as the hip is locked. These two joints, locked in opposition to one another, are important in holding the figure erect. The knee, lying slightly behind the center of grav-

ity of the body and locked from one direction, combined with the hip lying slightly in advance of the center of gravity and locked in the opposite direction, produces a mechanical equilibrium.

THE BONES OF THE LOWER LEG. The *tibia,* or *shin bone,* the principal bone of the lower leg, articulates above with the thigh bone, and below, by a hinge joint, with one of the tarsal bones of the foot. The shaft of the tibia is triangular in section and is thick because it supports the weight of the body; its front ridge and much of its inner surface are superficial. At its lower end, the bone expands to both sides; the projection on the inner side forms the so-called *inner ankle bone.* The *fibula,* the smaller bone of the lower leg, is very slender because it serves only for muscular attachments, supporting no weight. It is rigidly joined to the outer side of the tibia at both its upper and lower ends. Its upper extremity shows on the surface slightly below the knee joint; its shaft is hidden by overlying muscles; and its lower extremity projects to form the *outer ankle bone.* The outer ankle bone is situated lower and slightly farther back on the foot than the inner ankle bone. Both bones of the lower leg contribute to the shape of the ankle joint. A transverse hollow on the lower end of the shin bone accepts a drum-shaped bone of the foot; a projection of the shin bone on the inside and the lower end of the fibula on the outside hold this drum in place, the whole forming a hinge joint. The action at this joint allows the foot to be flexed or extended only, giving motion in the same plane as the motion at the knee.

The *patella,* the *kneecap,* is somewhat triangular and is situated, in the standing position, in front of the upper leg bone with its lower edge at the level of the knee joint. The tendon of the front thigh muscles connects to the top of the kneecap, surrounds it, and merges with the fibers of the *ligamentum patellae,* a nonelastic strap which in turn connects the kneecap to the lower leg bone. The kneecap, by being so embedded in connecting tendon, has no direct articulation with the leg bones; its position in relation to them changes when the knee is bent. The kneecap serves to protect the front of the joint as well as to increase the leverage of the thigh muscles.

The principal differences in the actions of the leg and arm occur in the forearm and lower leg. The twisting of the forearm changes the position of the wrist hinge in relation to the elbow hinge, whereas the lower leg, unable to twist, keeps the hinges of ankle and knee in the same plane. Furthermore, the wrist gives freer motion than the ankle; and, because it is capable of actions beyond those allowed by a true hinge, it gives additional motion as well.

THE MUSCLES OF THE HIP

The hip muscles, located at the side and back of the pelvic region, are the glutaeus maximus, glutaeus medius, and tensor fasciae latae. The *glutaeus maximus,* the *buttock muscle,* arises from the back end of the iliac crest, from the sacrum, and from the coccyx. It is the largest and strongest muscle of the whole body. Its deep fibers, passing between muscles at the back of the leg, are inserted into the shaft of the upper leg bone below its upper extremity. Its superficial fibers are inserted into the *iliotibial band,* the broad fibrous band extending down the outside of the upper leg. The characteristic rectangular form of the buttock as seen from behind is made principally by a deep overlay of fat rather than by the muscular shape. The glutaeus maximus is the extensor of the hip joint, pulling the leg backward in walking or jumping and helping to hold the body in a standing position.

The *glutaeus medius* arises from the upper portion of the flared surface of the ilium, beneath the iliac crest, and is inserted into the head of the upper leg bone. Although its back portion is partly covered by the glutaeus maximus and its front edge covered by the tensor fasciae latae, nevertheless it is mostly superficial, forming the side of the hip. The function of the glutaeus medius is to abduct the leg (raise it to the side), using the neck of the upper leg bone as a lever. The *tensor fasciae latae* arises from the front point of the iliac crest, passing obliquely downward and backward across the hip joint, and is inserted into the iliotibial band at the side of the leg. In the standing position, the outlines of the muscle can seldom be seen. When the leg is flexed at the hip joint, the muscle folds upon itself, bunches, and becomes more noticeable. Acting upon the iliotibial band, it helps raise the leg to the side; and, in conjunction with the glutaeus maximus, it steadies the figure in standing.

THE MUSCLES OF THE LEG

The leg muscles can be most simply divided into five groups, three for the upper leg and two for the lower leg.

THE MUSCLES OF THE UPPER LEG are divided into three main groups: one group at the front straightens the leg at the knee; an opposing group at the back bends the leg at the knee; a third group on the inside of the leg, arising from the bottom part of the pelvis, acts on the hip joint to bring the leg inward.

The *front group of the upper leg* comprises four muscles, the rectus femoris, vastus lateralis, vastus medialis, and sartorius. The *rectus femoris* arises from the pelvis at a point somewhat below the front end of the iliac crest and descends vertically, and its flattened tendon is inserted into the top of the kneecap. The superficial fibers of this tendon are extended over the surface of the kneecap, to be fused with the ligamentum patellae, therefore there is a second insertion of this muscle at the shin bone. The rectus femoris is the principal flexor of the thigh at the hip joint, and in conjunction with the vastus lateralis and vastus medialis is the extensor of the lower leg at the knee joint.

The *vastus lateralis* and *vastus medialis* lie behind and at either side of the rectus femoris. They arise respectively from beneath the head of the upper leg bone and from the inside surface of its shaft and are inserted into the kneecap by a tendon common to all three muscles. These three muscles show as a single diagonal mass at the front of the leg, following the diagonal direction of the upper leg bone. The vastus lateralis and vastus medialis, because of their common tendon and extended insertion into the shin bone, assist the rectus femoris in extending the lower leg. When this group is in a relaxed state, a band of thickened fascia will frequently cause a well-marked furrow across the form just above the knee. In a state of tension, this furrow disappears and the outlines of the three muscles can be seen. (See pages 71 and 73.) The *sartorius,* the fourth muscle of the front group of the upper leg, arises from the front end of the iliac crest adjacent to the origin of the tensor fasciae latae. It is long and thin, twists from the front of the leg above to the inner side below, where it crosses the knee joint, and is inserted into the inner surface of the shaft of the shin bone. It is not important in its influence on surface form or in its actions: it merely assists flexion of the thigh at the hip and of the lower leg at the knee.

66

The *back group of the upper leg* is composed of the three *hamstring muscles*: the biceps femoris, semimembranosus, and semitendinosus. They oppose the action of the front group by bending the leg backward at the knee; and they form a generally vertical mass in contrast to the diagonal mass of the front group. The *biceps femoris,* situated at the outer side of the group, has two heads. The long head arises from the rounded prominence of the ischium at the base of the pelvis; its thick body is directed vertically downward, ending in a strong tendon which crosses the knee joint on its outside surface and is inserted into the top of the fibula. The short head arises from the lower part of the shaft of the thigh bone; its origin and the upper part of its body are covered by the long head. The muscular fibers of the short head connect to the inner surface of the tendon of the long head which serves as a common tendon of insertion. This muscle is separated from the front group by a furrow, showing on the outside of the leg, and its tendon and lower fibers are clearly seen at the outside of the knee joint. The action of the biceps femoris is to flex the lower leg at the knee.

The *semitendinosus,* together with the *semimembranosus* superimposed upon it, lies parallel to the biceps femoris and adjacent to its inner side. Both muscles arise from the same prominence of the ischium which gives origin to the biceps femoris; their separate tendons pass across the inside of the knee joint to be inserted into the shaft of the shin bone. The semitendinosus and the semimembranosus, acting with the biceps femoris, flex the lower leg. The three muscles of the group together form a single smooth mass above; but below, they divide to pass on either side of the knee. The interval formed by this division is filled by a fatty pad.

The *inside group of the upper leg* muscles pulls the leg inward, opposing the action of the glutaeus medius of the hip. It is composed of four muscles, the pectineus, adductor longus, adductor magnus, and gracilis. The *pectineus* arises from the upper portion and front of the pubic bone, is oblique in direction, and is inserted into the upper part of the shaft of the thigh bone.

The *adductor longus* arises from the underside of the crest of the pubic bone, is parallel to and situated below the pectineus, and is inserted into the middle part of the shaft of the thigh bone. The *adductor magnus* arises from the whole length of the lower ridge of the pelvis; its mass is situated to the inside and to the back of the pectineus and adductor longus, and it is inserted into the entire length of the shaft of the thigh bone. These three muscles together form a single mass high on the inside of the upper leg; a mass thick and wide at the pelvis but tapering at the middle of the thigh. At the back, this mass merges with the mass of the back group of muscles, with no separation showing on the surface form; in the front, however, this inside group is visibly separated from the front group of muscles, the sartorius marking the division. The three muscles have a common action, adducting or moving the thigh inward toward the vertical center line of the body.

The *gracilis,* a flat superficial muscle, arises from the prominence of the pubic bone adjacent to the origin of the adductor longus, crosses the knee joint on its inside surface, and is inserted into the shin bone. The gracilis does not show individually on the surface form. Its functions are to help adduct the thigh and to flex the lower leg.

The principal *surface forms at the knee.* At the front, the kneecap with the fatty tissue immediately below it produces a clearly marked rectangular form when the joint is extended. Frequently the fatty

tissue will be divided vertically by the ligamentum patellae. When the knee is flexed, the fatty area is spread under pressure and disappears as an independent form. At each side of the knee is a strong vertical shape connecting the upper and lower legs; it is formed principally by the hamstring muscles which arise from the back of the upper leg and are inserted into the sides of the lower leg. On the inner side of the knee, this connecting shape is a broad smooth form wide enough to cover a part of the back of the knee as well. It is larger in the female because of overlaid fat. It is comprised of the tendons of four muscles arranged side by side as follows, reading from front to back: the sartorius, gracilis, semimembranosus, and semitendinosus. On the outer side of the knee, the companion connecting shape between the upper and lower legs is made by the thick tendon and muscle of the biceps femoris. At the back of the knee, between these two connecting pieces, is a pad of fat clearly bounded by two vertical furrows at its sides and by the horizontal skin fold below.

THE MUSCLES OF THE LOWER LEG are divided into two main groups to operate the hinge of the ankle: a group at the front, situated on the outside surface of the shin bone, flexes the foot and extends the toes; and a group at the back, having an opposing function, extends the foot and flexes the toes.

The *front group of the lower leg* comprises three muscles, the tibialis anterior, extensor digitorum longus, and peronaeus tertius. The *tibialis anterior* arises from the outer condyle of the shin bone and from the upper half of the shaft; the muscle and its long tendon lie adjacent to and on the outer side of the shaft of the bone. The tendon crosses at the ankle to the inner surface of the instep to be inserted into the base of the metatarsal bone of the big toe. The fleshy mass of the muscle above can be seen on the surface form and the tendon crossing the ankle is frequently very prominent. By its action of raising the instep, it is one of the flexors of the foot.

The *extensor digitorum longus* arises from the outer condyle of the shin bone and from the upper three-fourths of the fibula, and its body lies adjacent to the tibialis anterior. It terminates in a flat tendon which divides into four separate strands crossing the upper surface of the instep and is inserted into the phalanges of the four lesser toes. Its primary action is to extend (lift) the toes, but it also assists in flexing the foot. The *peronaeus tertius* is a small muscle which so merges with the extensor digitorum longus that the two appear as one muscle. It arises from the lower third of the fibula and is inserted into the metatarsal bone of the little toe. It assists in flexing the foot. The extension of the big toe is effected by a deep muscle of the lower leg, the *extensor hallucis longus*. Its tendon emerges from between the tibialis anterior and the extensor digitorum longus. Only the tendon of this muscle is shown in the plates.

The *back group of the lower leg* is composed of five muscles, opposing the action of the front group. Two are situated on the outside of the group and are directed toward the outer ankle bone; they are the peronaeus brevis and peronaeus longus. A single companion muscle, the flexor digitorum longus, is situated on the inside of the group and is directed toward the inner ankle bone. Finally, at the back of the group are the two calf muscles, the soleus and gastrocnemius, which extend to the heel. The *peronaeus brevis* arises from the lower two-thirds of the fibula. Its tendon passes behind the outer ankle bone, then, turning forward, is inserted into the metatarsal bone of the little toe. When the muscle contracts, the ankle bone, acting like a pulley on the tendon, extends the foot by pulling the instep downward.

The *peronaeus longus* arises from the head and upper two-thirds of the fibula. Its fibers descend vertically, ending in a long tendon which is superimposed upon the peronaeus brevis. This tendon also

68

passes behind the outer ankle bone and turns forward; it then crosses the underside of the foot and is inserted into the metatarsal bone of the big toe. The peronaeus longus also extends the foot by using the ankle bone to change the direction of the muscle pull, the same pulley arrangement as for the peronaeus brevis. These two muscles show only rarely on the surface form, but the tendon of the peronaeus longus is well marked immediately above the ankle bone. The *flexor digitorum longus,* pointing toward the inner ankle bone, arises from the back of the shin bone, but its origin and the greater part of its length are covered by the calf muscles. The lower part of the muscle becomes superficial, and its tendon passes behind the inner ankle bone, turns forward, and divides into four separate strands as it traverses the underside of the foot. These are inserted into the phalanges of the four lesser toes. This muscle extends the foot and flexes the toes.

The *soleus,* one of the *calf muscles* of the lower leg, arises from the upper third of the fibula and from the shin bone. Its body is wide and flat at the middle of the leg, but it tapers downward and is inserted into the heel bone by the strong and thick *Achilles' tendon.* Its inner edge shows most clearly where it makes a strong diagonal ridge on the surface form on the inside of the leg. The action extends the foot by raising the heel. The *gastrocnemius,* the second calf muscle, arises in two separate heads from the condyles of the upper leg bone. The two heads emerge side by side from between the hamstring tendons and continue adjacent to one another for the whole length of the muscle. The inner head is the thicker and more strongly marked on the surface form. Both heads expand and thicken as they extend downward, superimposed on the soleus, and both terminate abruptly in a broad tendon which continues to the heel. Just above the insertion at the heel it merges with the tendon of the soleus to form the thickest and most prominent tendon of the body. The gastrocnemius acts with the soleus to extend the foot and to keep the body erect in a standing position. Because of its origin on the upper leg bone it also acts on the knee joint.

The inversion and eversion of the foot at the ankle (that is, the turning of the sole of the foot toward the inside and toward the outside) are not movements of the ankle joint itself but are made possible by the articulations between the tarsal bones and by the looseness of the ligaments at the ankle. The actions are produced by those lower leg muscles which connect to the metatarsal bones; the tibialis anterior inverts the foot, and the peronaeus tertius and peronaeus brevis evert it.

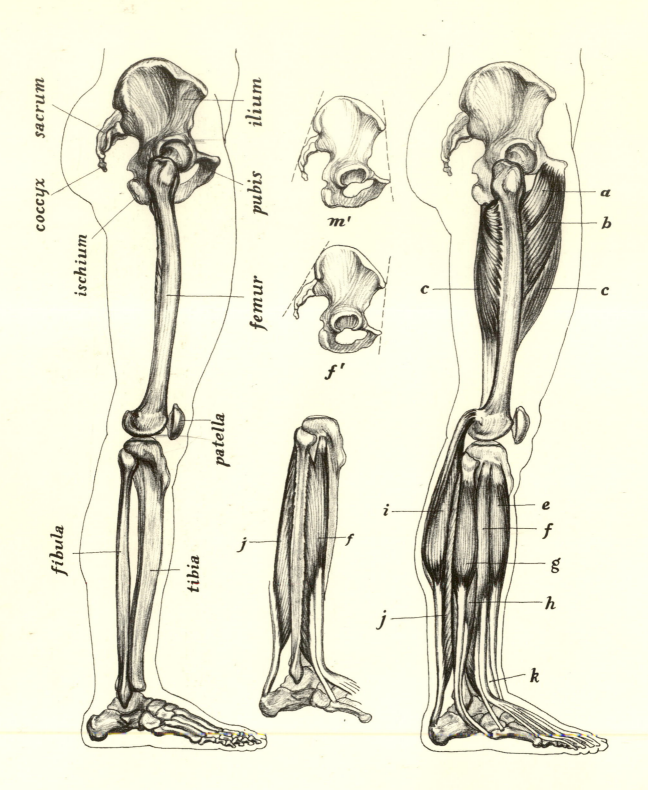

sacrum

ilium

coccyx

pubis

ischium

femur

patella

fibula

tibia

m'

f'

a

b

c · · · · c

i · e

f

g

h

j

k

j · f

a. Pectineus
b. Adductor longus
c. Adductor magnus
e. Tibialis anterior
f. Extensor digitorum longus and peronaeus tertius
g. Peronaeus longus
h. Peronaeus brevis

i. Gastrocnemius
j. Soleus (tendon joins with tendon from i)
k. Tendon from extensor hallucis longus (a deep
 muscle not shown)
m'. Male pelvis
f'. Female pelvis

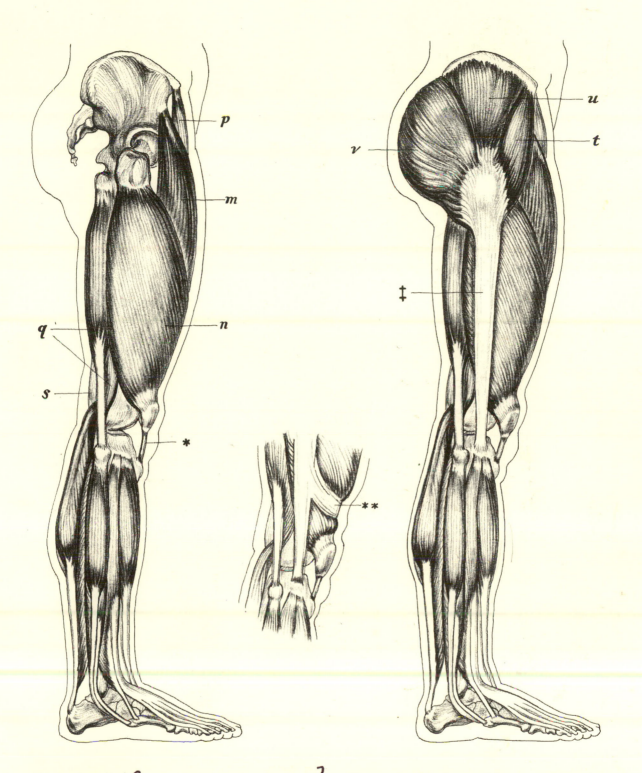

m. Rectus femoris 10
n. Vastus lateralis 8.
p. Sartorius
q. Biceps femoris 1
s. Semitendinosus 9
 * Ligamentum patellae
t. Tensor fasciae latae
2

3 u. Glutaeus medius (covered by an aponeurosis not shown)
11 v. Glutaeus maximus (the deep fibers of the lower part extend to the femur between muscles q and n)
 ‡ Iliotibial band (part of the deep fascia arising chiefly from muscles t and v)
** The band of fascia above the knee

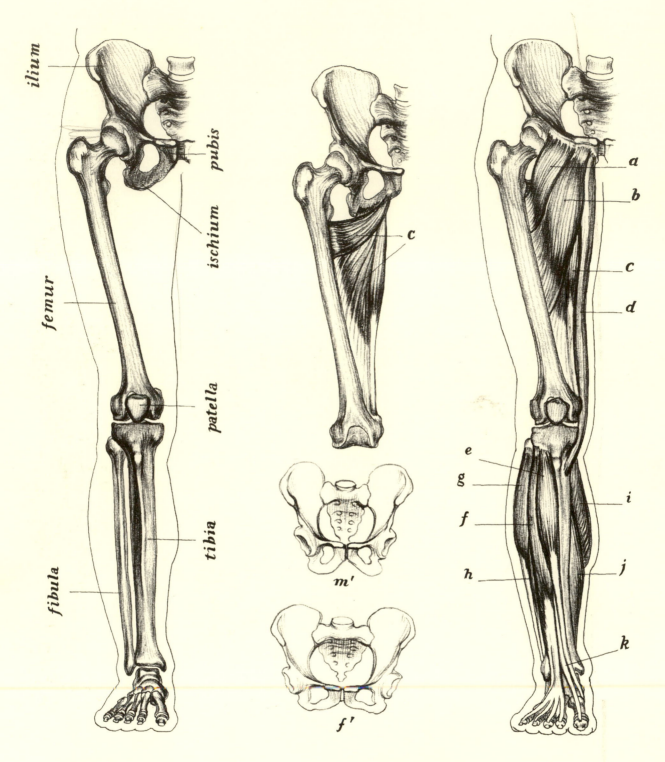

ilium

pubis

ischium

femur

patella

tibia

fibula

c

a

b

c

d

e

g

f

h

i

j

k

m′

f′

a. Pectineus
b. Adductor longus
c. Adductor magnus
d. Gracilis
e. Tibialis anterior
f. Extensor digitorum longus and peronaeus tertius
g. Peronaeus longus

h. Peronaeus brevis
i. Gastrocnemius
j. Soleus
k. Tendon from extensor hallucis longus (a deep muscle not shown)
m′. Male pelvis
f′. Female pelvis

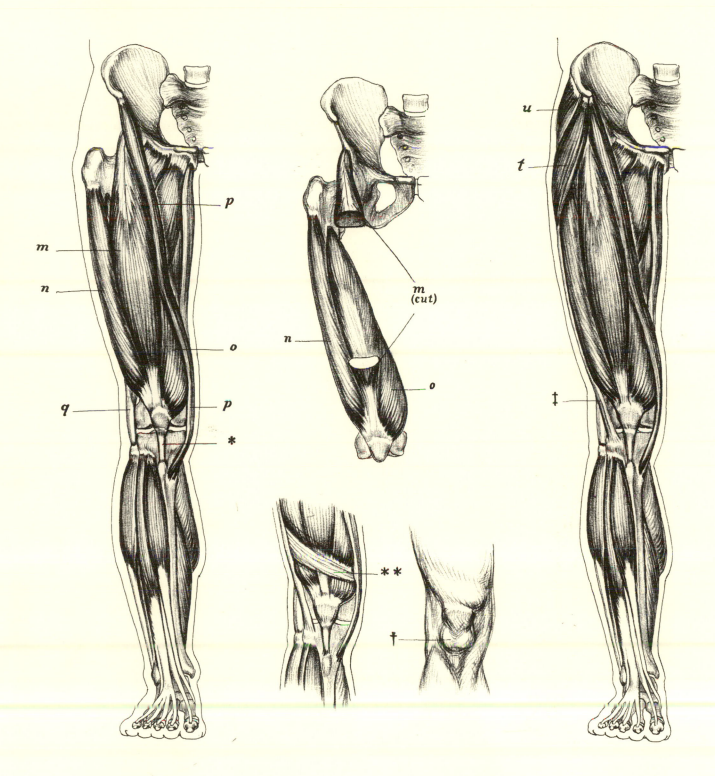

m. Rectus femoris
n. Vastus lateralis
o. Vastus medialis
p. Sartorius
q. Biceps femoris
* Ligamentum patellae

t. Tensor fasciae latae
u. Glutaeus medius
‡ Iliotibial band
† Fatty tissue
** The band of fascia above the knee and its effect
 on surface form

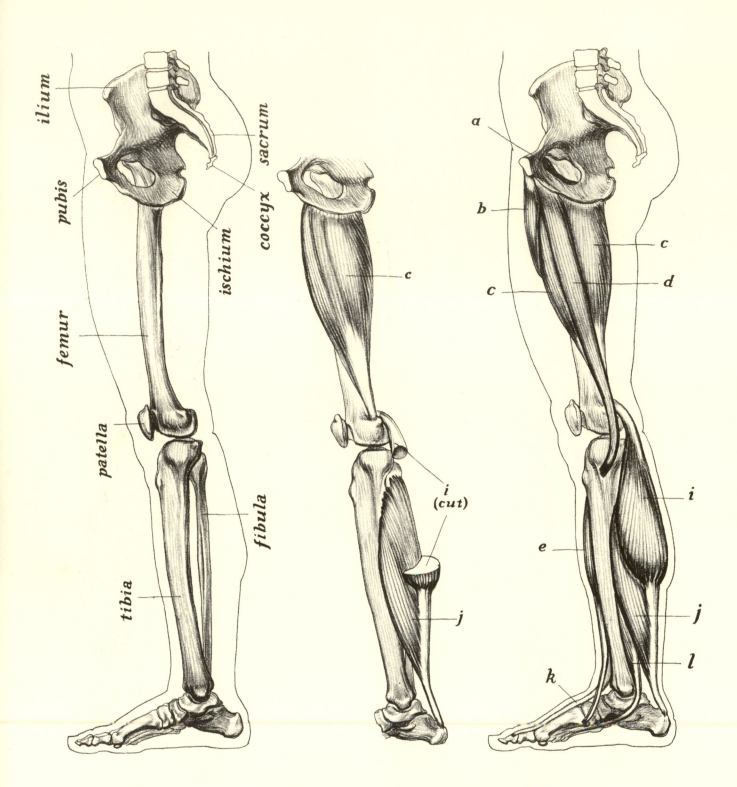

ilium

pubis

sacrum

coccyx

ischium

femur

patella

fibula

tibia

c

i (cut)

j

a

b

c

d

c

e

i

j

l

k

a. Pectineus
b. Adductor longus
c. Adductor magnus
d. Gracilis
e. Tibialis anterior

i. Gastrocnemius
j. Soleus (joins with *i* in common tendon to heel)
k. Tendon from extensor hallucis longus (a deep muscle not shown)
l. Flexor digitorum longus

74

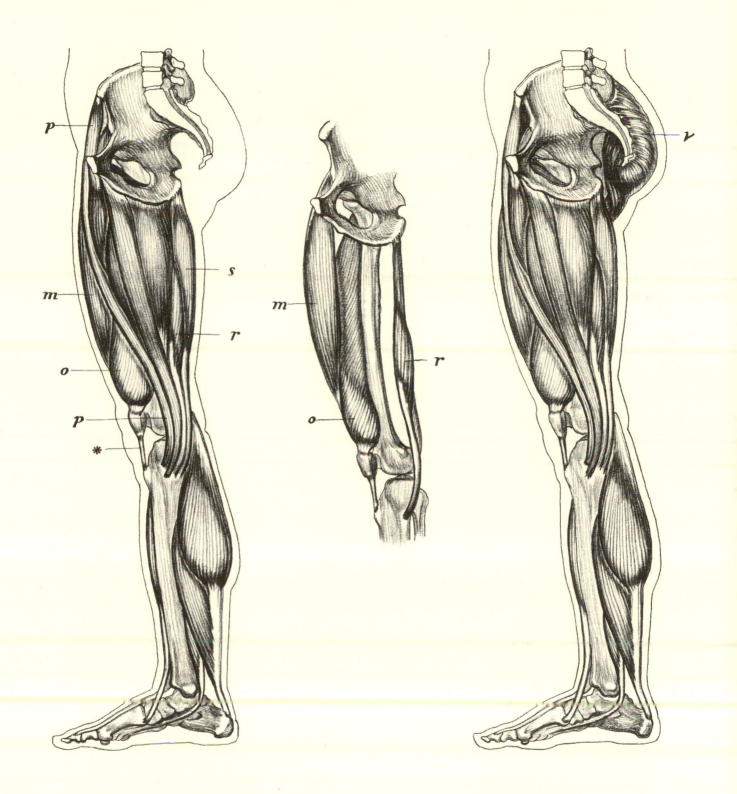

m. Rectus femoris
o. Vastus medialis
p. Sartorius
* Ligamentum patellae

r. Semimembranosus
s. Semitendinosus
v. Glutaeus maximus

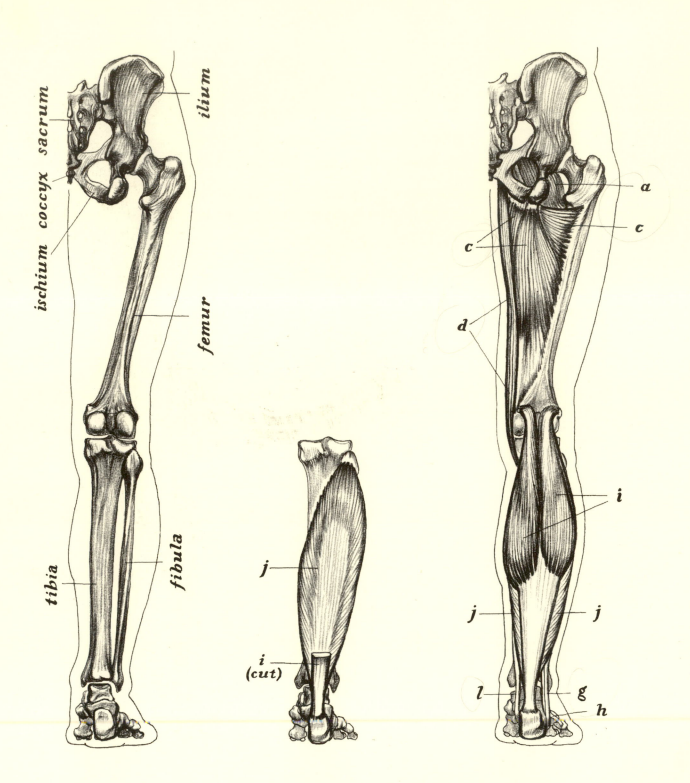

ischium coccyx sacrum

ilium

femur

fibula

tibia

j

i
(cut)

a

c

c

d

i

j *j*

l *g*

h

a. Pectineus
c. Adductor magnus
d. Gracilis
g. Tendon from peronaeus longus

h. Tendon from peronaeus brevis
i. Gastrocnemius
j. Soleus (joins with *i* in common tendon to heel)
l. Tendon from flexor digitorum longus

76

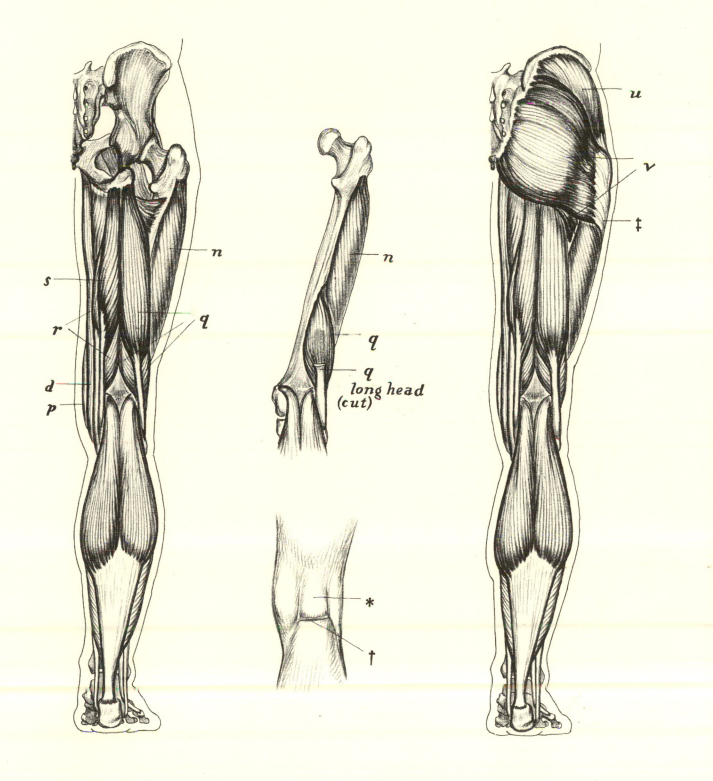

d. Gracilis
n. Vastus lateralis 3
p. Sartorius
q. Biceps femoris 4
r. Semimembranosus
s. Semitendinosus 5

u. Glutaeus medius 2
1. v. Glutaeus maximus (the deep fibers of the lower part extend to the femur)
‡ Iliotibial band
* Fatty tissue
† Cutaneous fold

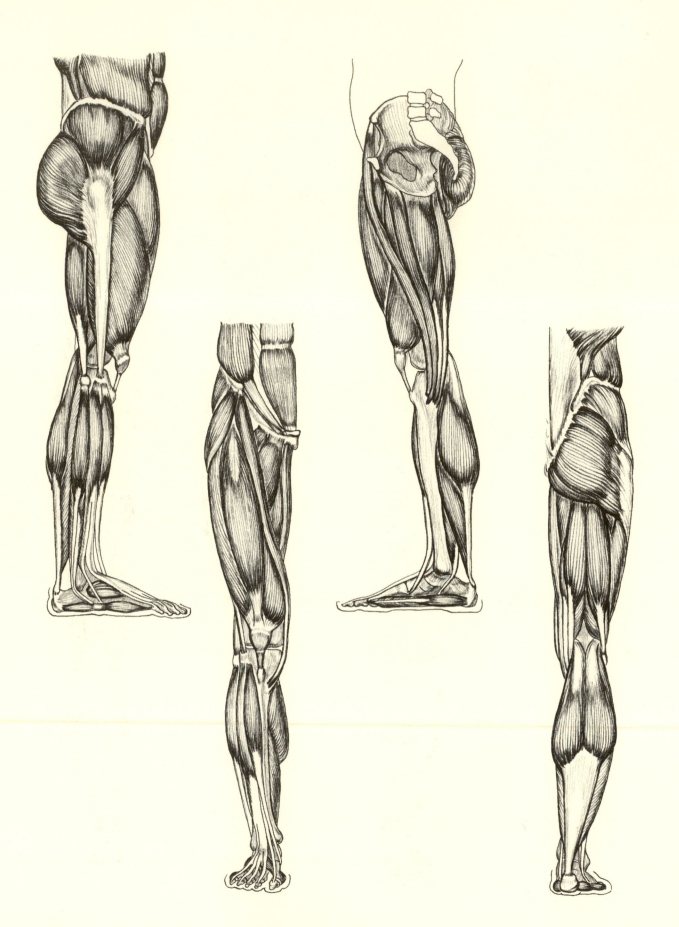

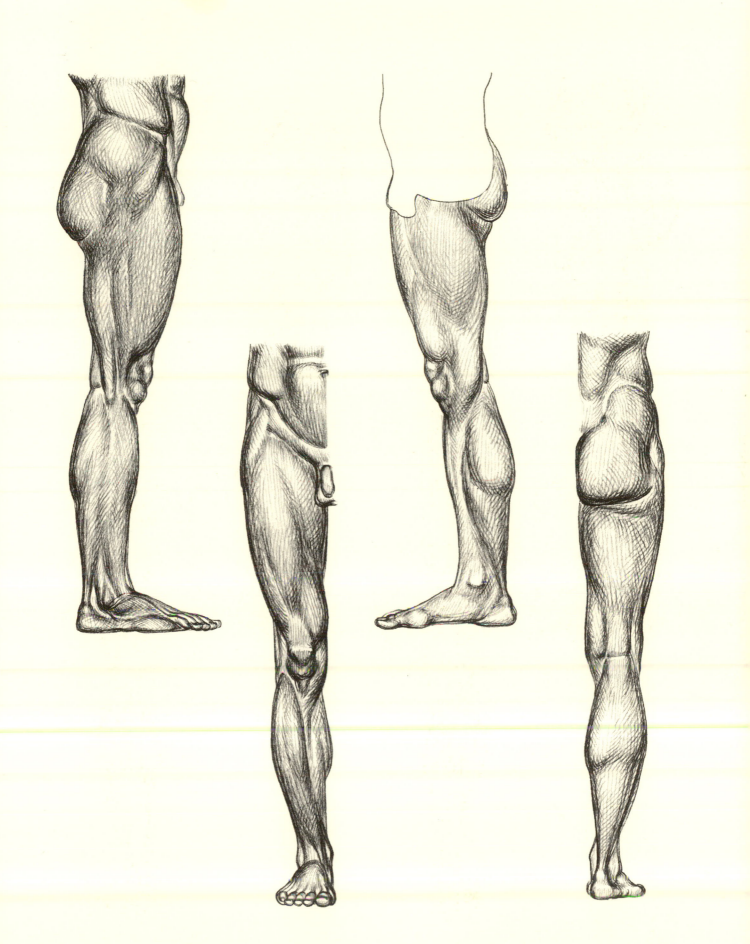

THE MOVEMENTS OF THE HIP

The hip is a ball-and-socket joint, the principal motions of which are flexion (leg forward), extension (leg backward), abduction (leg moved out to the side), and adduction (leg brought inward). The less important motions of circumduction and rotation are not illustrated.

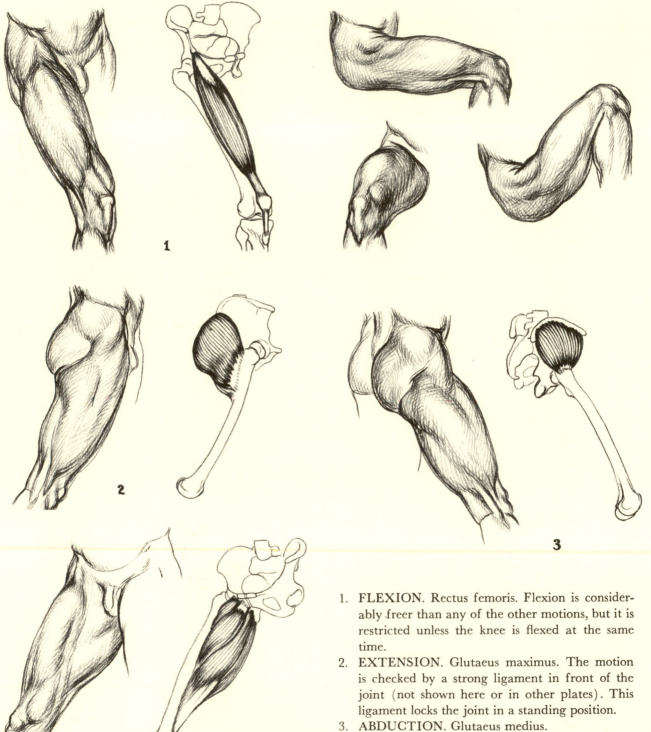

1. **FLEXION.** Rectus femoris. Flexion is considerably freer than any of the other motions, but it is restricted unless the knee is flexed at the same time.
2. **EXTENSION.** Glutaeus maximus. The motion is checked by a strong ligament in front of the joint (not shown here or in other plates). This ligament locks the joint in a standing position.
3. **ABDUCTION.** Glutaeus medius.
4. **ADDUCTION.** Adductor magnus, adductor longus, pectineus.

THE MOVEMENTS OF THE KNEE

The knee is a hinge joint, allowing the principal movements of flexion (the leg bent at the knee) and extension (the leg straightened). In a standing position the joint is locked by its surrounding ligaments.

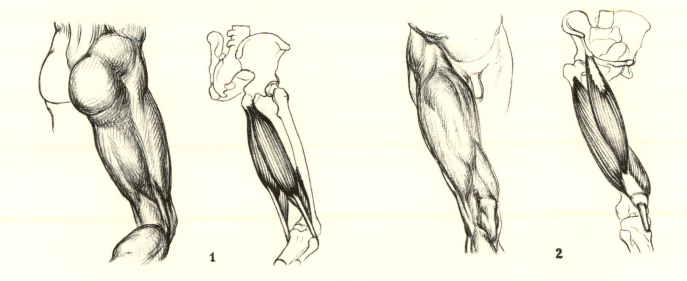

1. **FLEXION**. Semitendinosus, semimembranosus, and biceps femoris.
2. **EXTENSION**. Rectus femoris, vastus lateralis, vastus medialis. The tendons from these muscles unite to join to the kneecap; some of their fibers extend over the kneecap to connect with the ligamentum patellae. The pull on the lower leg is exerted by the ligamentum patellae.

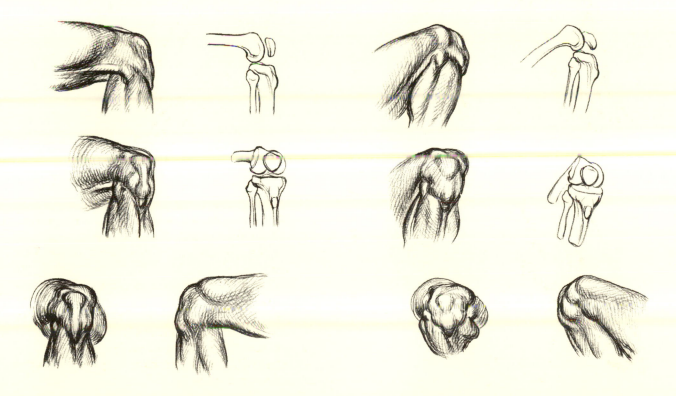

THE MOVEMENTS OF THE ANKLE

The ankle is a hinge joint allowing flexion (the front of the foot lifted) and extension (the heel lifted). The slight lateral movements, inversion and eversion of the foot, are not functions of the bone joint itself. These lateral movements are made possible only by the looseness of the ankle ligaments.

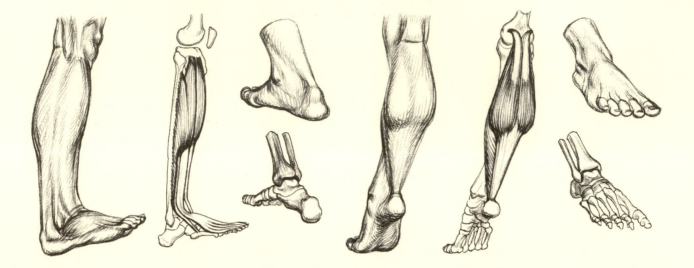

FLEXION. Tibialis anterior, extensor digitorum longus, and peronaeus tertius.
EXTENSION. Gastrocnemius and soleus.

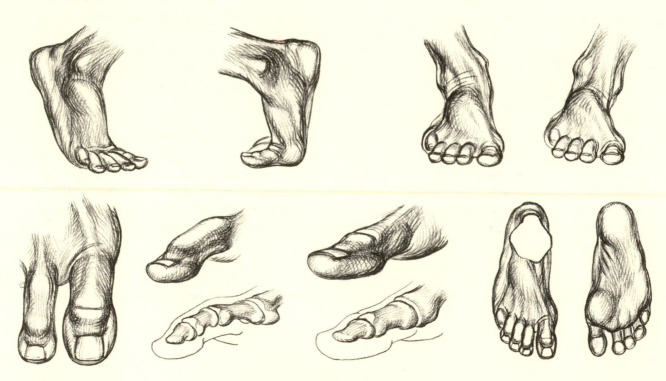

THE FOOT

The formation of the foot differs from that of the hand in several very important respects. Because the foot is primarily a support for the weight of the body, it is constructed in the form of two arches, a main longitudinal arch from the heel to the ball of the foot, and a secondary transverse arch across the instep. The strength of the longitudinal arch is due to its height, to the great size of the heel bone and to the thickness of the metatarsal bone of the big toe. The phalanges of the toes, compared to those of the fingers, are very short and, except for those of the big toe, very delicate as well. Finally, the movements of the ankle joint and of the toes are greatly restricted in comparison to the movements of corresponding parts of the hand.

THE BONES OF THE FOOT

The bones of the foot are divided into three groups: the tarsal bones, which form the heel and part of the instep; the metatarsal bones, which complete the instep; and the phalanges of the toes.

There are seven *tarsal bones,* of which only one articulates with the bones of the lower leg. This tarsal bone has, on its upper surface, a projection similar to a half drum, its convexity fitting into a corresponding concave surface on the underside of the shin bone. The extension of the shin bone (forming the inner ankle bone) and the lower end of the fibula fit down on either side of the drum, making a mortiselike joint capable of motion forward and back only. This articulating tarsal bone is supported by the tarsal bone which forms the *heel.* The heel is the largest bone of the foot and receives the thrust of the body weight at the back of the longitudinal arch. The five other tarsal bones are small and fit together at the apex of the arch, which is completed by the long metatarsal bones. Slight motion is possible between all the tarsal and metatarsal bones, thus distributing the shocks of walking or jumping through a springy rather than a rigid bone structure.

The five *metatarsal bones* are long bones corresponding to the metacarpal bones of the hand. They join the cluster of small rectangular tarsal bones which are situated at the high part of the instep. Consequently, the metatarsal bones form the front part of both the longitudinal and transverse arches of the foot. The upper extremities of the metatarsal bones articulate with the tarsal bones and with one another by means of slightly curved articular surfaces which permit only a very restricted gliding motion. They extend downward and forward and their free ends are held in relation to one another by a strong transverse ligament.

The metatarsal bone leading to the big toe is much thicker than the corresponding bone of the hand leading to the thumb and it has much less freedom of motion because it is held in position by ligaments.

The metatarsal bones leading to the lesser toes differ from the metacarpals leading to the four fingers by being parallel to one another and by being thinner. Each metatarsal bone is joined to one of the toes by means of a smooth rounded surface inserted into a hollow on the first phalanx of the toe. These joints hinge the toes to the foot, permitting flexion, extension, and the lateral motion of spreading the toes.

The *phalanges* are three in number for each of the lesser toes, and two for the big toe. They are similar to the phalanges of the fingers except that they are much shorter and, in the case of the lesser toes, much thinner as well. The joints between them are true hinges; each phalanx terminates in two rounded articular surfaces fitting into two corresponding hollows in its connecting phalanx, thus precluding any lateral motion. The terminal phalanx in each case ends in a flattened form to which the nail is attached.

Two very small round bones, shown in the plates beneath the metatarsal of the big toe, are *sesamoid bones*. They are embedded in tendons, not shown, and serve to assist the action of tendons in sliding across the joint. They occur frequently at other joints as well. The kneecap is usually considered a sesamoid bone because it is invested in tendon and is situated at a joint.

THE MUSCLES OF THE FOOT

The muscles of the foot, with one exception, are all placed either between the metatarsal bones, where they do not influence surface form, or on the underside of the foot, where they are hidden by a very thick padding of fibrous tissue. Only those muscles which appear at the sides or top of the foot are shown in the plates. Consequently, in this book, many more muscles of the foot have been omitted from the text and plates than have been omitted in the case of any other part of the body.

The principal *extensors of the toes* are situated in the lower leg, the *extensor digitorum longus* for the lesser toes and the *extensor hallucis longus* for the big toe. Assisting these muscles is the *extensor digitorum brevis*, a muscle of the foot, placed on the outer and upper surface of the instep. It arises from the tarsal bones just below the outer ankle bone and divides into four separate parts which are inserted into the phalanges of all but the little toe. It is seldom evident on the surface form.

The *flexors of the toes* are the *flexor digitorum longus*, a muscle of the back group of the lower leg, and a group of muscles on the underside of the foot, only one of which is shown. This one, the *flexor hallucis brevis* arises from the underside of a tarsal bone; the body of the muscle lies under the front part of the longitudinal arch, showing on the inner side of the foot; and its tendon is inserted into the first phalanx of the big toe, on which its acts as a flexor.

Situated likewise on the inner border of the foot, under the back part of the longitudinal arch, is the *abductor hallucis*. It arises from the heel bone; its body forms, with the flexor hallucis brevis, the appearance of a single muscle; and it terminates in a long tendon reaching to the first phalanx of the big toe. Its action is to spread the big toe by moving it inward. Showing on the outer border of the foot is the *abductor digiti quinti*. It arises from the heel bone and is inserted into the first phalanx of the little toe. As the body of the muscle extends along the foot, it becomes constricted at the base of the metatarsal of the little toe, appearing to form two separate pads, one on the outer side of the heel and a second, larger and farther forward, on the outer side of the ball of the foot. The action of this muscle is to spread the little toe.

84

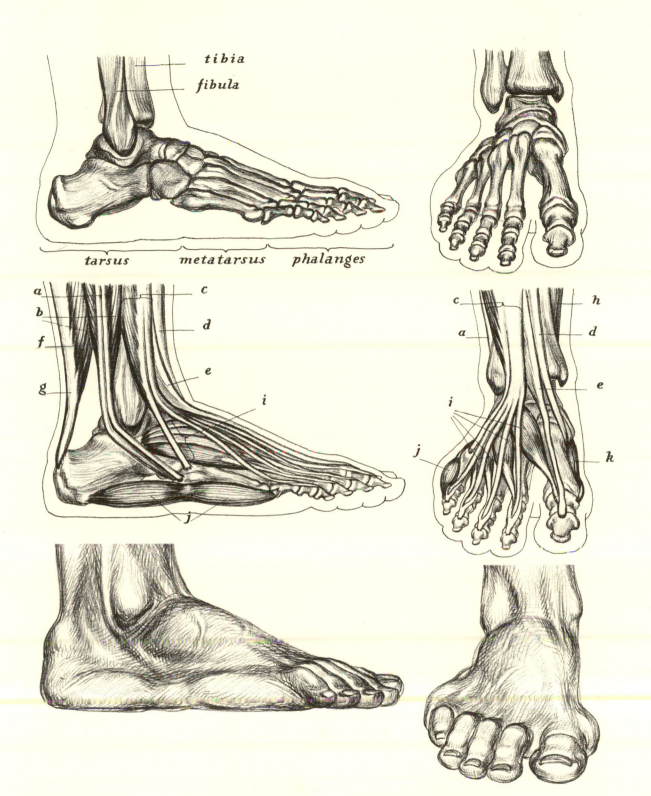

tibia

fibula

tarsus metatarsus phalanges

a. Tendon from peronaeus longus (it extends underneath the foot to the base of the first metatarsal bone)
b. Peronaeus brevis
c. Extensor digitorum longus and peronaeus tertius
d. Tibialis anterior
e. Extensor hallucis longus

f. Soleus
g. Tendon from gastrocnemius
h. Flexor digitorum longus
i. Extensor digitorum brevis
j. Abductor digiti quinti
k. Abductor hallucis and flexor hallucis brevis

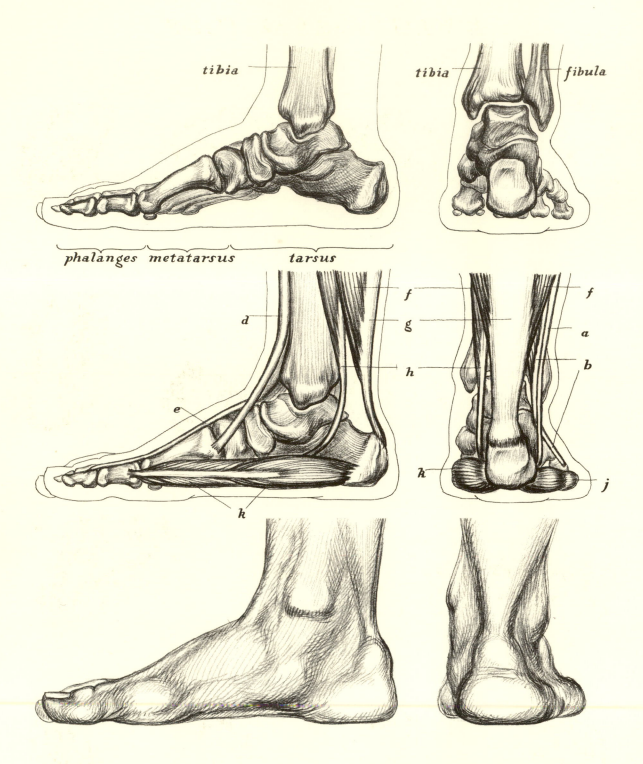

a. Tendon from peronaeus longus (it extends underneath the foot to the base of the first metatarsal bone)
b. Peronaeus brevis
d. Tibialis anterior
e. Extensor hallucis longus
f. Soleus

g. Tendon from gastrocnemius
h. Flexor digitorum longus (it extends under the foot, dividing into four tendons which attach to the last phalanges of the second, third, fourth and fifth toes)
j. Abductor digiti quinti
k. Abductor hallucis and flexor hallucis brevis

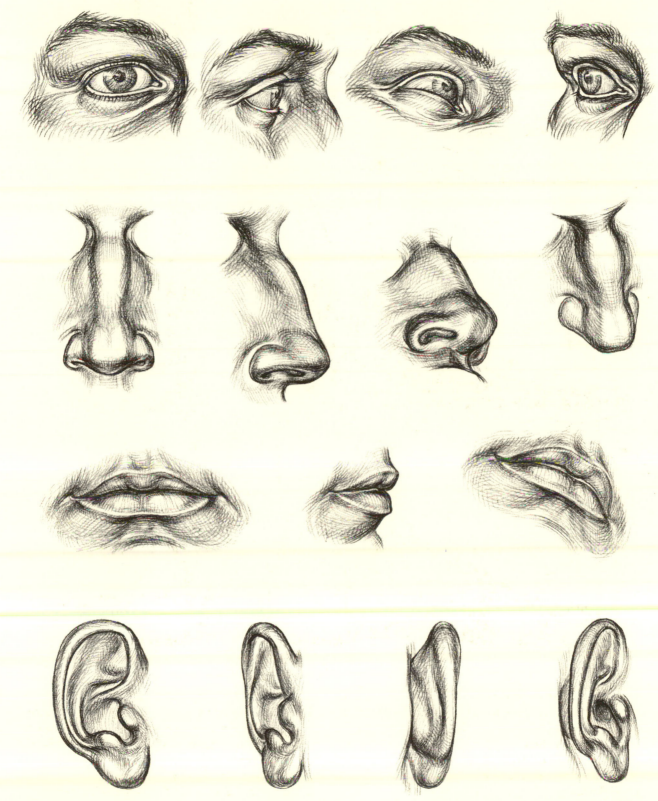

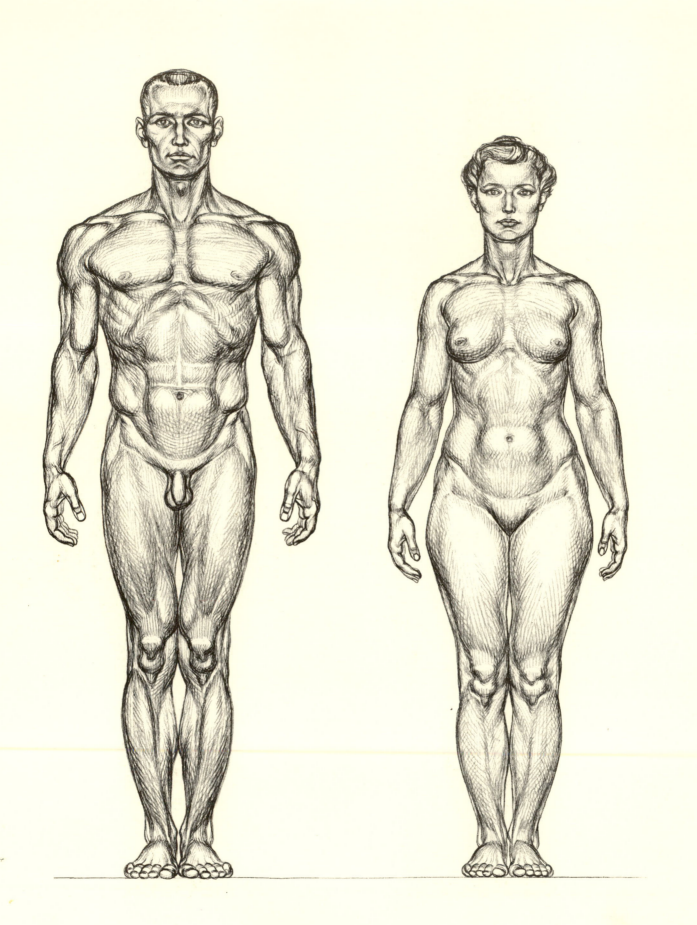

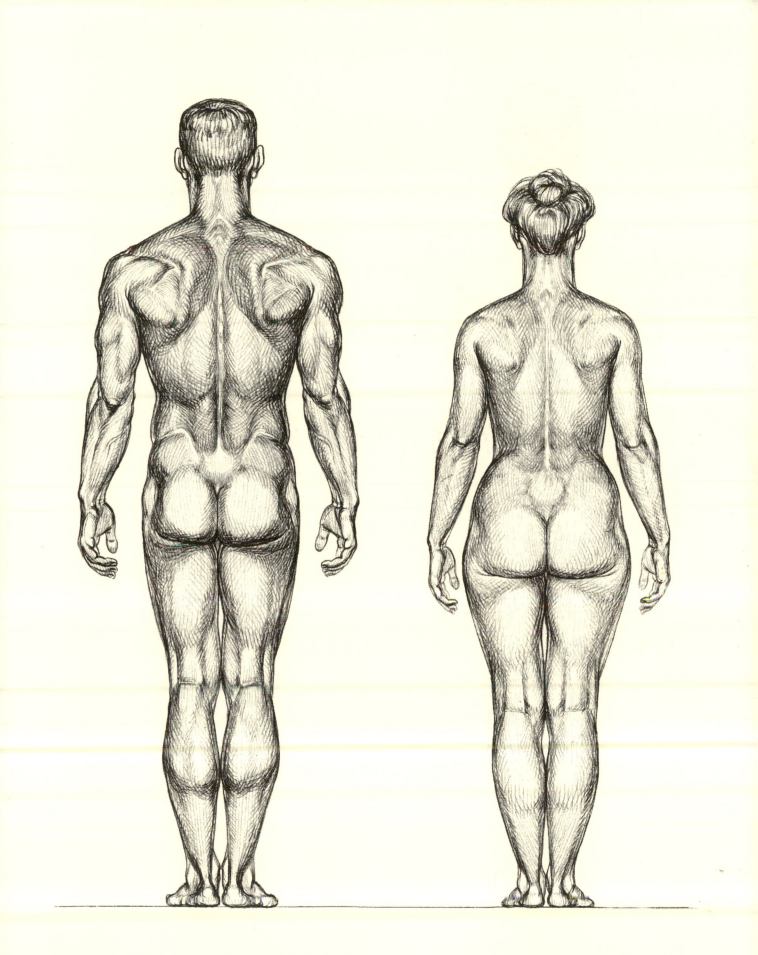

89

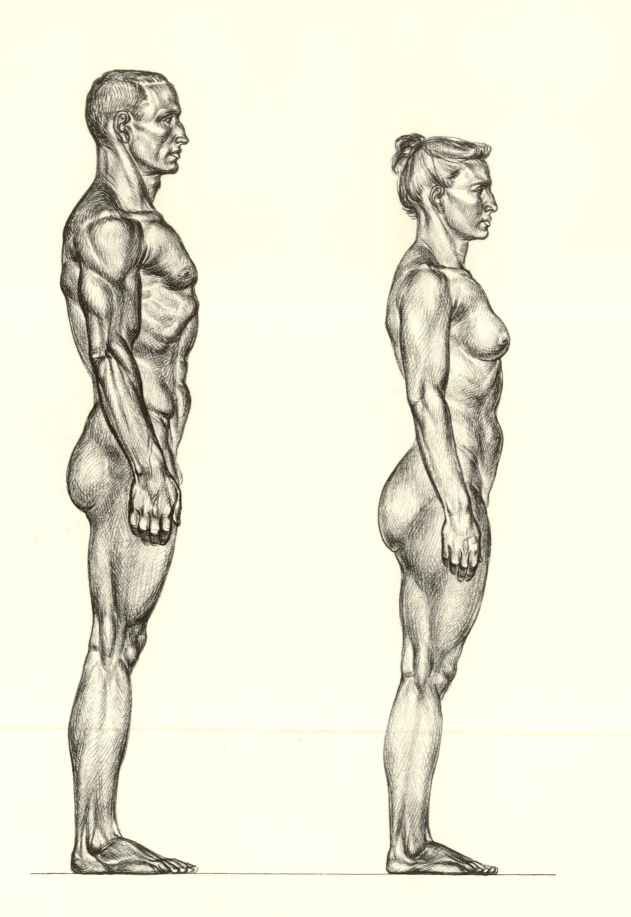

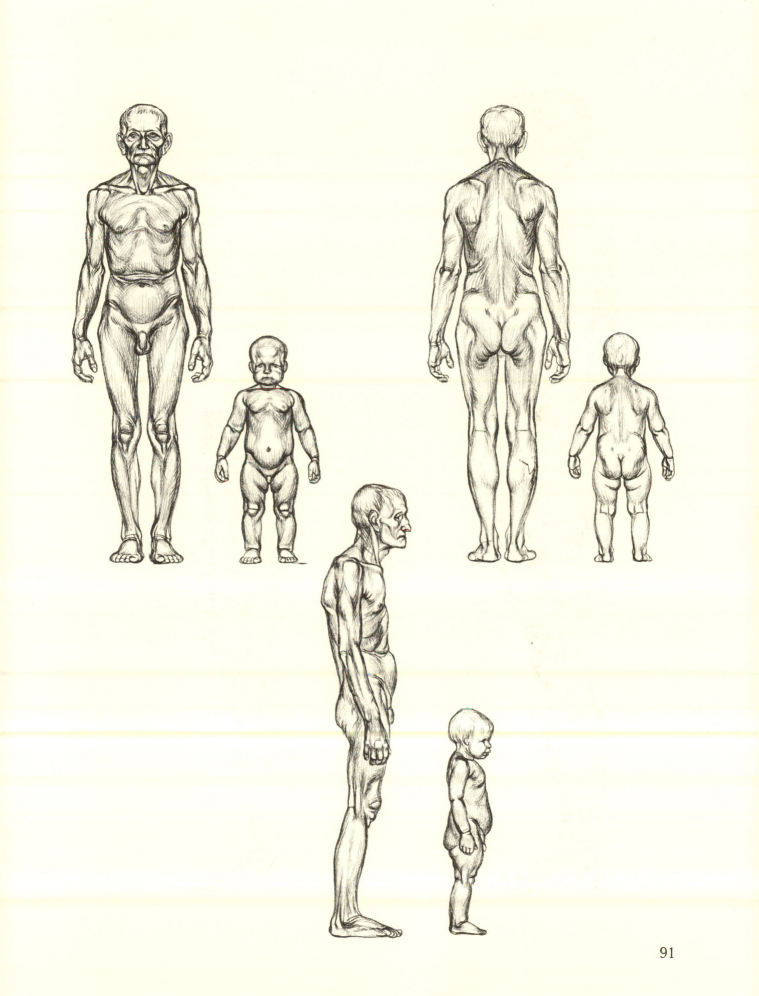

INDEX